THE STREET

The Street

A PHOTOGRAPHIC FIELD GUIDE TO AMERICAN INEQUALITY

EDITED BY
Naa Oyo A. Kwate

PHOTOGRAPHS BY
Camilo José Vergara

FOREWORD BY
Darnell L. Moore

RUTGERS UNIVERSITY PRESS
NEW BRUNSWICK, CAMDEN, AND NEWARK, NEW JERSEY, AND LONDON

Library of Congress Cataloging-in-Publication Data

Names: Kwate, Naa Oyo A., editor. | Vergara, Camilo José, photographer.
Title: The street: a photographic field guide to American inequality / Naa Oyo A. Kwate;
 Photographs by Camilo José Vergara.
Description: New Brunswick: Rutgers University Press, [2021] | Includes bibliographical references.
Identifiers: LCCN 2020031208 | ISBN 9781978804500 (paperback) | ISBN 9781978804517 (hardcover) |
 ISBN 9781978814226 (epub) | ISBN 9781978814233 (mobi) | ISBN 9781978814240 (pdf)
Subjects: LCSH: Equality—New Jersey—Camden. | Equality—New Jersey—Camden—Pictorial works. |
 Income distribution—New Jersey—Camden. | Income distribution—New Jersey—Camden—Pictorial works. |
 Social justice—New Jersey—Camden. | Social justice—New Jersey—Camden—Pictorial works. |
 Streets—New Jersey—Camden. | Streets—New Jersey—Camden—Pictorial works.
Classification: LCC HM821 .S755 2021 | DDC 305—dc23
LC record available at https://lccn.loc.gov/2020031208

A British Cataloging-in-Publication record for this book is available from the British Library.

∞ The paper used in this publication meets the requirements of the American National Standard for Information Sciences—Permanence of Paper for Printed Library Materials, ANSI Z39.48-1992.

www.rutgersuniversitypress.org

Manufactured in the United States of America

E3

Woforo Dua Pa A

CONTENTS

PART III
Social Stories and Stigmatized Space

FOREWORD

The many narrow streets and wide avenues I walked down in Camden, New Jersey, during my childhood in the 1980s seemed to be haunted by the ghosts of a past more glorious than the present I confronted as a youth. There was the home that I had come to love and that which was depicted in the public imagination as a site of vice and loss.

The media depicted Camden as a "hood" and founded its judgment on the prescriptive words of politicians and pollsters who decried my city as one of the most violent and economically devastated urban spaces in the United States.

The gaze of the public was centered on a built environment that appeared broken as well as the state of the mostly Black and Latino/a working poor people as that which was best characterized as hopeless. One only needs to drive through the neighborhoods to find proof—abandoned properties, ragged asphalt streets, unkempt housing projects, the flow of crack cocaine, and much else. To the broader world these were sure signs of Camden's decay—almost always rendered as the consequence of the glaring presence of the Black and Latinx residents who were evidence of the ostensible signs of nihilism, hopelessness, and cultural pathology, but I knew differently.

Beyond the sensational takes on Camden as one of New Jersey's most infamous ghettos, those of us who called Camden home understood what onlookers missed. We made home and provision and hope and community and family and joy possible in spite of what we lacked because of the years upon years of calculated political disenfranchisement, scapegoating, loveless economic policies, White flight, dislocation, and greed.

As Susan Sontag wrote in her celebrated work *On Photography*, "To photograph people is to violate them . . . it turns people into objects that can be symbolically possessed. Just as a camera is a sublimation of the gun, to photograph someone is a subliminal murder—a soft murder, appropriate to a sad, frightened time."[1] In many instances, that is what photographs of Camden did. Throughout my life I have stared upon stills that caged the subjectivities of Camden's people in the public imagination as if the interior lives of our people were nonexistent. The outsiders never peered behind the window frames of our homes. They did not capture what we made possible. They did not stare upon the many displays of radical love and care that sharpened our admiration for the place we were socialized to shame. They missed the tight-knit networks of neighbors who cared for one another as if they were family. They missed the ways we sometimes turned abandoned lots into grounds for play and exploration. They did not care to capture or write about the various instances of collective struggle that allowed so many families to emerge after clashes with law enforcement. They missed the presences of life that animated our streets, corner stores, parks, liquor stores, churches, mosques, bus stops, schools, and eateries with a type of hope that resisted hopelessness.

Outsiders' interpretations of Camden, whether by way of photographs or media reportage, lacked the type of critical analysis that assessed the contexts that foreground many of Camden's problems. *The Street: A Photographic Field Guide to American Inequality*, in contrast, reverts and corrects the myopic gaze of such onlookers. It is a critical work that testifies to the spirit that is situated behind and within the photos that capture so much of what so many have chosen to forget. Camden is alive like so many predominantly Black and Latinx working poor spaces in the United States. They have always been.

To critically assess Camden as a built environment is to read our home as a consequence of the collusion of anti-Blackness, neoliberal urban renewal policy making, and capitalistic-oriented politicking. *The Street* is a book I needed as I grappled with the complicated histories of the city I love as a budding adult. And the contributors write with nuance and critical

generosity, unlike the photographers, reporters, and social scientists who have framed Camden as everything except a site of possibility. The writers use Camden as a starting place in their effort to grapple with many consequences of systemic oppression in urban spaces within the United States.

What better time than now to insert Camden into a broader story on urban space, race, and class during a time of rapid gentrification and its concomitant features like urban education reform and development that permeates our now? This book surfaces amid the calloused and celebrated murder of Black and Latinx urban spaces and the ontological onslaught of the people within them.

That is why we need writers and thinkers who are prepared to grapple with the ways America strangulates the interior lives of the imagined dispossessed. We need nothing short of a reckoning with the powerful gaze of those who view our most loving spaces through an optic of what bell hooks calls White supremacist capitalist patriarchy.

DARNELL L. MOORE

NOTE

1 Susan Sontag, *On Photography* (New York: Dell, [1977] 1982), 14.

THE STREET

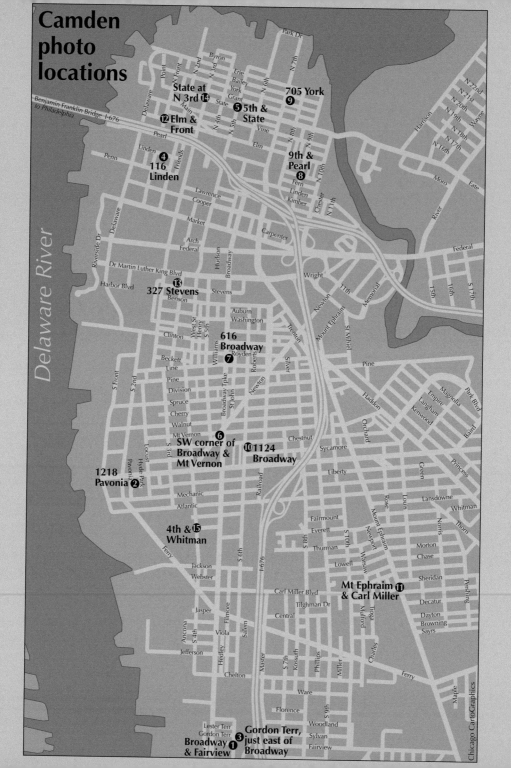

Camden photo locations

Locations for all photos, Camden, New Jersey

INTRODUCTION

NAA OYO A. KWATE

George Swanson Starling fled the oppressive and violent racial climate that characterized Florida in 1945, where life was rigidly segregated by Jim Crow signage and social conventions that denied African Americans societal resources and public regard. One of millions of Black Americans who migrated from southern states to cities in the North and West, Starling settled in New York's Black Metropolis, Harlem. There, he thought himself free of the overt and legally codified racial exclusion that contoured life in Florida. It was to his dismay, then, that one evening in 1950, after he and a friend finished their drinks in a downtown bar, the bartender smashed their glasses under the counter rather than reusing them. This rebuke of the two men's participation in ordinary social activity stung because it was violent and subtle in equal measure: "There were no colored or white signs in New York. That was the unnerving and tricky part of making your way through a place that looked free. You never knew when perfect strangers would remind you that, as far as they were concerned, you weren't equal and might never be."[1]

In "a place that looks free," reminders of the many shades of inequality that define American social life are ubiquitous. They come not only from other people but also from the material world. Elizabeth Abel, in her book *Signs of the Times: The Visual Politics of Jim Crow*, asks: "What are the undeclared color lines that continue to delimit neighborhoods? What modalities of racism still fracture the social landscape after the dismantling of Jim Crow? Where would the racial signs of our times be situated and what language would they use?"[2] These signs, these reminders that some people are not equal and might never be, are still most acutely displayed and felt on the street, where people busy themselves with daily life: going to the

grocery store; lugging laundry bags; waiting for public transit; meeting friends, family, and neighbors. Public policies operate behind the scenes to create one or another kind of lives for people. But the street is where the intent and effects of these polices are laid bare. And so daily life often means enduring the indignity of police stops and searches, or spending extra time obtaining goods and services that are often in scarce supply.

Still, the street is where we find evidence of resistance against and respite from dominant interests and narratives that circulate about Black and Brown communities. As Lutie Johnson, heroine of Ann Petry's novel *The Street* (1946) found: "She never felt really human until she reached Harlem and thus got away from the hostility in the eyes of the white women who stared at her on the downtown streets and in the subway. . . . These other folks feel the same way, she thought—that once they are freed from the contempt in the eyes of the downtown world, they instantly become individuals."[3] Lutie's streets were not only risk but also refuge.

But what does a place that merely looks free look like? Where in urban streetscapes should we search for evidence that society has sorted people, communities, and resources unequally? How obvious is that evidence likely to be? And how much will it vary from city to city? Field guides are texts that allow readers to identify a phenomenon quickly and accurately, regardless of their skill level or expertise. For example, a field guide to North American birds comprises primarily photographs of different species in their natural habitats, accompanied by interpretive text, recognition tips, and concise, detailed profiles that are accessible and easy to use. As a visual dictionary, a field guide implicitly asks questions such as "Do you know the difference between an American gold-finch and a house finch?" or "What distinguishes male from female northern flickers?" American goldfinches are identifiable by their bright yellow (male, breeding) or olive (female) plumage, a penchant for perching on and eating seeds from slight weeds and flowers, and their tendency to call out during flight. Fairly quickly, an amateur ornithologist will recognize them with little effort.

What tool, then, for students of American inequality, when its instantiations are often subtle, or else so pervasive they look like common sense? A field guide to American inequality would

need to ask (and answer) what social hierarchy looks like in urban built environments and would need to grapple with the multiple layers of meaning that imbue the physical infrastructure. Enter this book. Using Camden, New Jersey, as a case study, here is a field guide to visualize the codes, metaphors, policies, and social exchanges that characterize and contest inequality in the United States. Often, field guides are meant to be authoritative and exhaustive, a kind of portable library. An ambitious endeavor for this book, to be sure—it would be a Sisyphean task to catalog exhaustively street-level cues of inequality. We focus instead on a specific set of policies and practices, infrastructure and identities, resources and risks that tell us much about what American inequality looks like, and what it means for social life, health, and a sustainable city.

The notion of field guides for the built environment has been applied to analyses of American sprawl, where manifestations such as category killers (big-box stores that dominate an entire retail sector) and locally unwanted land uses (LULUs) are illustrated.[4] The arresting language is purposeful. Planners often employ neutral and legal terminology to frame land-use issues, perhaps in an attempt to be less off-putting to decision makers, but that kind of framing is also easier to ignore.[5] One can imagine that calling a slipshod, poorly designed building a NOPE—Not on Purpose Edifice—might underline more clearly for policy makers how land use reveals neighborhood investment, literal and figurative, and how architecture can mark neighborhoods as less valuable/less valued, their residents as problematic or irrelevant. To that end, field guides are useful because naming is critical to identification and identification is crucial to action.

If "society can be known by the landscapes it creates and nurtures," then we have much to gain from looking at landscapes in order to understand inequality in American society.[6] Aerial photos taken from between 1,000 and 2,000 feet ideally capture the scale of sprawl, establish a "visual inventory" of local landscapes, and document the spread of development in a way that is accessible to those without technical training.[7] In contrast, to explore how inequality is felt in the everyday, we need intimate photographs: scenes captured at street level, imbued with the vibes, sounds, and granular detail of urban life. These we find in Camilo José Vergara's photographs of Camden, a

productive point of departure for visualizing inequality. Not because, as it is so often depicted in the media and understood in popular imagination, the city constitutes a singular expression of failed urbanity. Rather, the visuals of Camden's streets and the city's well-documented history of postindustrial segregation and disinvestment are echoed in cities across the United States. Indeed, even as George Swanson Starling watched his barware being destroyed in Harlem, a Camden resident "recalled that the nearby American Restaurant would grant requests for a drink of water, but would destroy the glass afterwards."[8] We can learn a lot by reading Camden's streets, and take that literacy to conditions in other cities such as Chicago, Detroit, and Baltimore.

And yet, as it relates to American inequality, it would be a mistake to assign fixity to images of urban landscapes. That is, a picture of a vacant lot is indicative of many institutional processes and ought not be defined wholly as a single manifestation of inequality. Vergara's photographs show us not only what the particularities of inequality look like in Camden but also what we ought to look for to understand streetscapes in marginalized American communities more broadly. Rather than starting with the essay and thinking about how these photographs are illustrative of the topic at hand, the point is to start with the photograph and think about how we ought to interpret what we see. The United States, as a society that is wasteful and excessively values newness and youth, leaves its landscapes to dereliction in ways that suggest Americans accept the attitude, "Why not waste places as well as things?"[9] Boarded-up buildings and vacant lots are too common features of urban America, as is their simplistic and paradigmatic interpretation—"poverty." We need more depth in reading streetscapes, and this field guide attempts to delve beyond the parsimony of "bad neighborhoods," to think about the processes that brought conditions into being and how residents contend with them. Multiple interpretations are of course possible, and the essays in this volume present a particular set of readings from a wide-ranging roster of scholars representing multiple disciplines, theoretical perspectives, and professions. The writers leverage Vergara's images to foreground aspects of inequality that are less often discussed.

The methodology employed in this field guide can be used to probe inequality in other cities and the emerging forms it takes. Prior to HOPE VI, the Department of Housing and Urban Development's 1992 housing program that led to the demolishing of public housing projects, certain cues on city maps were nearly foolproof wayfinders for these housing developments: "superblocks" and discontinuous street grids; often isolated locations; and expressways, railroad tracks, or both as perimeter barriers. Today, those elements may be more useful to discover historical inequalities more than current ones. New field markers have begun to serve as indicia of housing inequalities. As low- and middle-income Black neighborhoods are remade to suit, attract, or take on the veneer of affluent White residents, houses may be styled "gentrification gray," as Washington, DC, observers have called it—a shade of paint along with a particular aesthetic in house address numbers.[10] The repetitive aesthetic underlying gentrification gray is also evident in residential interiors, as gray laminate floors, gray walls, and granite countertops pervade the "renovation" of early twentieth-century homes long neglected and now subject to infusions of capital. Building features tell us something about the political economy of place, even across cities with drastically different architecture and land use. The presence of goods and services, what they offer, and where they lie in urban space are reliable markers of inequality, particularly in a country where consumption is central to national identity. So too does the absence of typically taken-for-granted environmental features, such as street trees. A lack often instigated by urban renewal, an insufficient tree canopy then perpetuates a cascade of other inequalities such as the health risks born out of heat islands.[11] This field guide advocates for attention to the quotidian of the street as the entrée to understanding present inequalities and past injuries.

Each essay is "titled" with a numeral assigned in order of appearance in the volume and a subtitle that identifies the topic. In numbering the essays, we emphasize that the book is by nature a limited cataloging and visual interpretation of urban inequalities. At the same time, counting them also underscores that despite interrogating but a select group of elements, they are numerous nonetheless. All of the entries in the field guide are structured identically to support a consistent

approach to the visual interpretation of the photographs. The opening text defines the particular issue of inequality at hand, outlining what we know, providing extant evidence, and discussing what it means for America's social fabric. In the next section, "Field Markings," the author responds most directly to what is in Vergara's image, explaining how what is visible illuminates inequality and drawing attention to what is invisible, but lurking off-camera, driving the circumstances we see. Finally, in "Field Notes," authors expand the scope of their analysis, considering their topics from diverse vantage points: describing the way forward in research and articulating how the inequality in question has been contested or relates to other forms of social hierarchy, how core constructs ought to be reconceptualized, and the like. Taken together, the pieces expose the workings of American inequality: how it is made, sustained, challenged, and embodied.

The book comprises four parts. Part I, "State Systems and Predatory Profit," considers some of the policies and practices by public and private actors that are fundamental to everyday life in the United States: transportation, credit and finance, and hospitals and health care. These essays show how the state has built, dismantled, and failed to regulate systems and services that critically impact quality of life and life chances. Norman W. Garrick interrogates automobile-centric planning policies that make cars the sine qua non of freedom, to the detriment of the built environment and social life—consequences that fall heaviest on African American and poor communities. Anthony S. Alvarez examines a two-tiered banking system that builds wealth for the privileged and makes life harder for others. Focusing on the predatory inclusion of payday lenders that brings high profits to lenders and immense financial risks to borrowers, Alvarez shows that a new definition of financial citizenship is needed, one that is founded on freedom from exploitation and a right to respect. Alecia J. McGregor studies the closure of hospitals—an indispensable part of health care—in a context where some patients and procedures are more profitable than others. Her essay underlines what is at risk when communities lose lifesaving resources.

Part II, "Symbols and Sentiments," focuses on the symbolic meanings embedded in the built environment and the interpretations residents and policy makers make about the physical

landscape. Zaire Z. Dinzey-Flores explodes the notion of housing physical characteristics as neutral or universal, detailing how they are powerful symbols of the self, race, and class, and how aesthetics both embody and reproduce inequality. Jacqueline Olvera looks at displays of collective grief in public space and the ways in which they are variously read: Is it art or disorder? Who gets to say? What does it mean for communities to bear witness to the pain wrought by symbolic violence? Naa Oyo A. Kwate explores the conflicting messages that appear in urban space, arguing that one manifestation of inequality is dissonance in the built environment—between aesthetics and cost, between disorder as public harm or gritty authenticity, and other ways. Stacey Sutton unpacks how signs and elements in the built environment are received and interpreted by insiders and outsiders in communities before and after gentrification, while making clear that gentrification is not mere symbology—it is a spatial expression of wealth inequality predicated on asymmetries in power, preexisting housing discrimination, and tropes about "the ghetto."

Part III, "Social Stories and Stigmatized Space," turns to narratives: narratives that have been left out of common discourse; narratives that attempt to make sense of (or obscure) race, class, ethnicity, and the history of inequality in this country; and narratives about people that are brought to life in stigmatized spaces. Jacob S. Rugh reflects on the forgotten Latino story and the insufficiency of the Black/White binary, arguing that Americans lack a consensus on what exactly happened to disadvantaged cities and that Latino communities need to be recentered in the narrative of urban history. Jay A. Pearson contends that European constructions of race and inferiority underlie the structural inequalities around which opportunity coheres. He asserts that Whites enjoy a dominant position as much because of the ability to impose a particular story about race and an interpretive lens on others as because of institutions and legislation that promote White supremacy. Mindy Thompson Fullilove evaluates the erosion of physical space and the stress it produces—but also the ingenuity and tenacity of those who must live with systemic disinvestment. Arguing that a long history of policies and practices dating to the Cold War has ultimately undermined the integrity of the urban ecosystem, she questions facile narratives

around resilience. Naa Oyo A. Kwate appraises fast food's conflicted status as both the national food in a country where "American" is coded White and a lowbrow cultural product that is coded Black. Examining the ways in which fast-food outlets reveal the flight of capital, problematic aesthetics, and stereotypes, she finds that these restaurants reflect the stigmas that pervade Black consumption and Black space.

Finally, Part IV, "Safety and Security," troubles both concepts, focusing on Black and Brown youths from birth through adolescence. Kellee White examines infant mortality as the physical embodiment of social and economic inequities. Arguing that current biomedical thinking fetishizes personal responsibility, making mothers ultimately responsible for infant health, she shows that Black babies and their mothers lack the security that would promote infants' living past their first birthday. Janice Johnson Dias analyzes urban childcare and the trade-offs poor mothers must make in caring for their children—safety versus psychosocial development. She asserts that poor mothers, who lack the means to access private childcare, must rely on government facilities that make care coextensive with "safe" confinement. LeConté J. Dill reflects on the next major institution along children's developmental pathway—schools. She dissects the stereotypes that see children as failures, rather than the state policies that undermine school functioning, and the stigmatization and securitization that make schools less safe. Craig B. Futterman, Chaclyn Hunt, and Jamie Kalven close the part with an interrogation of the policing of Black and Brown youths. In-depth interviews with adolescents in Chicago show that safety, comfort, and privacy are privileges that these youths cannot count on. A pervasive atmosphere of threat and police impunity not only consigns teens to a world governed by different rules but also ultimately imperils how the law actually functions.

All of the essays are brief, but rich; they are meant to spark new thinking about how to interpret what is writ in city streets. More than that, this field guide aims to make itself obsolete, eventually. American goldfinches will always be American goldfinches. But there is no reason why American cities should remain visual dictionaries of a place that only looks free.

The inequalities illustrated herein reflect a long trajectory of decisions and actions. So too do the many forms of pushback. If identification is prerequisite to action, then the entries in this field guide are not merely taxonomy, but operation manual. Readers should be equipped to make sense of, be outraged by, and then work to dismantle American inequality.

NOTES

1 Isabel Wilkerson, *The Warmth of Other Suns: The Epic Story of America's Great Migration* (New York: Random House, 2010), 341.

2 Elizabeth Abel, *Signs of the Times: The Visual Politics of Jim Crow* (Berkeley: University of California Press, 2010), xvii.

3 Ann Petry, *The Street* (New York: Houghton Mifflin, 1946), 57.

4 Delores Hayden and Jim Wark, *A Field Guide to Sprawl* (New York: W. W. Norton, 2004).

5 Hayden and Wark, *Field Guide to Sprawl*.

6 John A. Jakle and David Wilson, *Derelict Landscapes: The Wasting of America's Built Environment* (Savage, MD: Rowman and Littlefield, 1992), 5.

7 Hayden and Wark, *Field Guide to Sprawl*.

8 Howard Gillette Jr., *Camden after the Fall: Decline and Renewal in a Post-industrial City* (Philadelphia: University of Pennsylvania Press, 2006), 31, e-book.

9 Jakle and Wilson, *Derelict Landscapes*, 12.

10 ElleMooreHP, "Went around the DC neighborhood that I grew up in taking pics of all the 'gentrification gray' houses. . . . They even have the same thin Art Deco font-style house numbers. My brother calls it 'flipper/investor gray,'" Twitter, October 7, 2019, 10:54 a.m., https://twitter.com/ellemoorehp/status/1181221360154107908?s=21.

11 Joyce Klein Rosenthal, Patrick L. Kinney, and Kristina B. Metzger, "Intra-urban Vulnerability to Heat-Related Mortality in New York City, 1997–2006," *Health and Place* 30 (2014): 45–60.

STATE SYSTEMS
AND PREDATORY PROFIT

Broadway and
Fairview, 2004

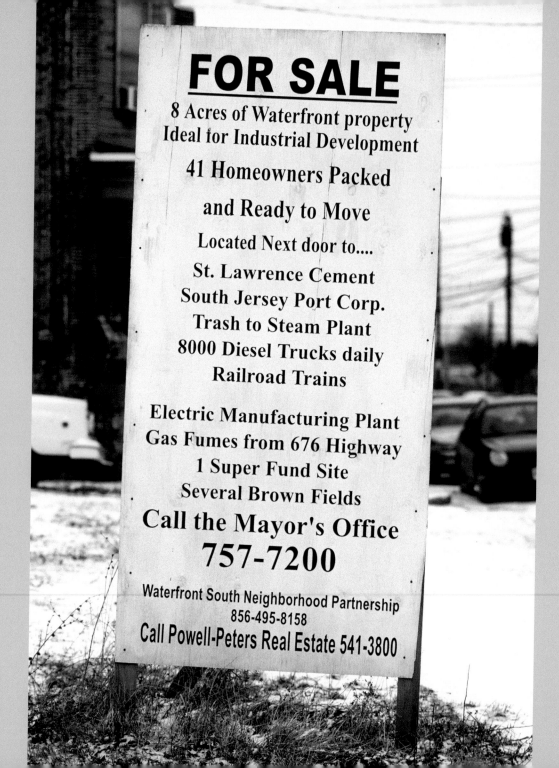

NO. 1 Racial Patterning of Travel in America

NORMAN W. GARRICK

Transportation and urban planning in the automobile era has failed the entire planet in fundamental ways. Under the assault of ubiquitous car ads, global societies have almost uniformly bought into the idea that cars are givers of freedom. This has resulted in an addiction so entrenched that we have become inured to the harm that is done to the environment, to our cities, and to many of our citizens. Our transportation system is a major contributor to carbon emissions, cars kill more than 1.3 million people each year globally, and urban sprawl—which is only possible because of car dependency—fuels a host of environment, social, and economic ill.[1] These issues affect all people on the planet, but the impacts are disproportionately felt by the poor globally—and, in the United States, disproportionately by racial minorities, especially African Americans.

The disparate negative impacts of the transportation system on various subgroups of the population are among the costs we seem to be willing to pay for the illusory—but effectively marketed—freedom of automobility. In fact, this issue is largely overlooked by transportation profession partly because it is so easy to ignore. You have to go digging into the data to understand the extent of the problem. But it is a real problem that has been documented by a handful of intrepid researchers.[2]

The race-based problems associated with our transportation system have many dimensions, but they are rooted in two main sources. The first has to do with where most racial minorities

live, or have been forced to live as a consequence of coercive and discriminatory transportation and land-use policies. The second component is one of economic reality: African Americans typically have lower incomes and much less wealth than other Americans and are placed at a disadvantage by our societal reliance on one of the most costly transportation system that has ever been devised.

Let us first deal with the issue of place. In today's America, African Americans are concentrated in neighborhoods that have been ravished by some combination of highway building and urban renewal, and that now suffer from severe disinvestment. This means that African Americans have much less proximate access to jobs, healthy food, services such as banking, and recreation. To meet these basic needs they often must find a way to travel to predominantly White suburbs. These are suburbs that are often built to be conveniently accessible only by people with cars.

The lower economic status of many African Americans also puts them at a disadvantage in accessing transportation services, the costs of which have increased significantly as we have become more auto reliant. Data from the U.S. Bureau of Labor Statistics show that at the turn of the 1900s, when transportation in cities was largely by foot and by tram, transportation took less than 5 percent of the average household income.[3] Today, more than 90 percent of the population nationwide commutes by car, and transportation eats up nearly 20 percent of household income. My own research identifies that transportation cost, as a percentage of household income, is much higher in states like Mississippi, which are more auto dependent.[4]

In other words, we have built a transportation system around a technology that is very expensive to own and operate. People or groups of people with lower incomes either are disenfranchised or must resort to extreme measures to maintain their access to the places, people, goods, and services that are necessary for the normal functioning of daily life. African Americans suffer greatly in this transportation regime. It is no wonder that often, when we see a car broken down by the side of the highway, the people involved are all too frequently Black folks.

This is a visual reflection of one accommodation that poor people must make to have access to their daily lives—they often are forced to drive a cheap "clunker" because that is all they can afford, and because not having a car is not an option if one is to have even the most marginal role in the economic life of many places in the country.

FIELD MARKINGS

Residential segregation restricts African Americans to physical surroundings that are often dispiriting and unhealthy, as a consequence of decades of disinvestment, and are often the host of the most noxious and unattractive land uses, including highways, waste facilities, and pollution-generating industries. African Americans suffer from a high rate of exposure to transportation-related pollutants and higher rates of traffic fatalities. Vergara's image captures so well the plight of urban America that it brings to my mind Childish Gambino's devastatingly depressing hit rap song from 2018 titled "This Is America." In this image we see a mayor's office that is trying to promote economic development in the city, but we see how impossibly long the odds are. The city is nominally trying to attract developers, but the sales pitch is less than compelling. The site is next to some of the worst polluters in the region—including a cement plant, a trash-to-steam plant, and 8,000 diesel trucks daily. The site also hosts a Superfund site and several brownfields. I do not anticipate that this site will be sold anytime soon without a massive intervention from the state and federal governments to clean up the problems.

This site is an extreme situation, but it represents unused or underutilized land all across the urban landscape of American cities. This is particularly true in cities with majority minority populations and in its most extreme form is seen in places like Gary, Indiana, and East St. Louis, Illinois, that are almost entirely Black. For many cities, reversion of urban land to wasteland reflects in large part federal urban and transportation policies enacted in the 1940s and 1950s.

Even in light of a long and painful history of discrimination and abuse relating to urban policies and accommodation in America, the 1950s confluence of race in conjunction with transportation and urban policy stands out in terms of its ongoing effects on the current condition of American cities. The toxic combination that led to the rapid demise of these cities in the 1950s was turbocharged by a flood of federal monies for suburban house purchase, urban renewal and highway construction. The specific federal projects that fueled these actions included the 1949 Housing Act and the 1956 Highway Bill.

The impact of these programs would have been enormous under any circumstance, but when combined with American race politics, the effects were especially devastating—not just for African Americans but for the country as a whole. Only in the last decade or so has mainstream America come to grapple with the full ramifications of historical injustices. Still, we tend to treat the issue as being one of misguided planning, ignoring the role that racial politics played in worsening the planning missteps of that era. We continue to ignore those sociopolitical forces at our peril.

FIELD NOTES

The ravages of 1950s era policies of urban renewal, highway construction, and suburban migration are writ large for all to see in the current physical condition of American cities large and small. Even after fifty years, the scars have never healed—and in fact have only grown more pronounced with the passage of time. Camden, New Jersey, shows all the hallmarks: highways that plowed through once vibrant neighborhoods and that now serve as permanent barriers dividing the city into bite-size sections; a downtown pockmarked with surface parking lots where businesses once thrived, and even more parking in garages on every block; streets converted to mini surface highways to facilitate the rapid flow of traffic heading out of town—streets

that are largely devoid of life. Anyone who dares walk risks being run over by hurried suburban-bound traffic. There are beautiful old buildings that are only partly occupied, and a few horrendous newer buildings that often look like prisons (usually constructed with government money). At the same time, there are plenty of newer, one-story buildings that are fast-food outlets, gas stations, or payday moneylenders—buildings that actually serve to convert the downtown from urban to suburban in character.

Beyond downtown, the story is just as dire in many neighborhoods, especially those closest to the central business district. In cities that are in better shape, these are often the most desirable neighborhoods. But in Camden, these areas are characterized by clumps of houses surrounded by weed-filled empty lots, and housing showing signs of severe neglect and decay, reflecting the economic distress of the owners. If these conditions sound familiar to those who have not been to Camden, it is because this description rings true for hundreds, if not thousands, of cities in distress, all across the country. How did this happen to so many well-made and once beautiful cities? It seemed almost systemic. And it is.

To better understand this phenomenon, we need to reflect on the transformations wrought under the auspices of the Housing Act of 1948 and the Highway Bill of 1956. The rapidity with which cities were transformed between roughly 1955 and 1965 is nothing short of astounding. I first became aware of just how monumental this change was for American cities at a San Francisco conference in October 2001. I was attending a talk by Shelly Poticha (who later went on to lead HUD's Office of Sustainable Housing and Community under the Obama administration) when she showed an aerial photograph of downtown Hartford taken in 1955 and then immediately followed it with one from the same vantage point, but this time in 1964. The audience reaction was palpable—one of shock and horror at both the nature and the rapidity of the change. The pictures showed the transformation of a large mixed-used, fine-grained neighborhood in Hartford, Connecticut, into a monolithic neighborhood of skyscrapers sitting on a gigantic podium hiding the parking—a transformation all done with federal monies.

That moment, seeing those two images back to back, has stayed with me since then, and it has been the motivating factor in much of my research going forward. The images have led me on a quest to document the changes that have occurred in specific cities around the country—to assess the impact of these changes on how people travel, and to explore the health and well-being of these cities.[5] Cognitively, our experience of cities is that they are relatively static—that they change slowly, if at all. Thus, it is hard for us to understand the correspondence between changes in policy and design and changes in the physical aspects of cities, since these physical changes are often gradual, taking hold over decades rather than years.

This is one reason why it is difficult for laypeople to comprehend the relationship between policy and the evolution of their city. But the once-in-a-lifetime, revolutionary changes that occurred in the 1950s and 1960s pose a different set of cognitive challenges. In fact, these wrenching physical transformations mutated the very essence of our cities. The psychiatrist and urban studies scholar Mindy Thompson Fullilove (see no. 10 in this volume) coined the term "root shock" to describe the effect of urban renewal on the community as a whole. She argues that renewal projects destroyed not only houses but also social bonds and familiar places.[6]

This, to me, captures the essence of the historical changes that we as a society have yet to come to grips with or to develop meaningful solutions for. Part of the reason for that might lie in what Jane Jacobs refer to as "mass amnesia."[7] Young people today, living in cities like Bridgeport, Connecticut, or Camden, New Jersey, will be surprised to know that their cities once had vibrant downtowns, that children walked to schools, that there were no freeways in the city, that many people did not need to own cars, and that people socialized in the city rather than at the mall. And if they did know, would they fully understand how their lives might be different if they lived in a place like pre-1950s Bridgeport? Given the results on the ground, it is not a stretch to say that we have had over the last sixty years an urban and transportation system that is actually anti-urban and antitransportation, and pro-car.

To top it all, these policies have directly targeted Black communities. To give but one example, in 2018, I was on a Congress for the New Urbanism panel reviewing applications from communities around the country vying to get their chosen city freeway on an annual list called "Freeways without Future." Communities hope to get their freeway on the list to draw national attention to their project; they hope to can gain traction in an uphill battle to get the state to remove crumbling infrastructure and to redevelop land—land that was blighted in the first place by the presence of the freeway.

Invariably, applications described how the freeway in question was built through the heart of the most prominent African American community in that city. I was aware of a number of nationally celebrated cases in which freeways were built in just this manner—Overtown in Miami and Claiborne in New Orleans are two such cases—but I had no idea just how widespread the practice was. I found reading these stories dispiriting. But at the same time, I was heartened by the fact that advocates are finally waking up to the past injustices related to the construction of the freeway system and are beginning to realize that inequity is an important part of the conversation.

In states like New Jersey and Connecticut, the mainstream is now becoming aware that our history of marginalizing our urban places is exerting a drag on our economies. This is because urban places are newly popular with both the young and the old—and maybe even many in between. And we are beginning to give lip service to developing the type of planning policies that have led to the revitalization of cities such as Seattle and Washington, DC. But we are still a long way from acknowledging the racial components that resulted in policies and attitudes that placed a stranglehold on so many places that were deemed "urban."

We can indeed learn a lot from the revitalization of Seattle and Washington, DC. But there is a disconcerting side to the resurgence of those cities—the very nature of the renewed prosperity means yet another wave of disruption to the existing population, who are often poor and

from racial minorities. The issue of gentrification and affordable housing is of huge concern in cities that are reversing the tide of urban decay.

The outcomes in these cities suggest that as a society we are still not at the stage where we are capable of developing policies for creating inclusive communities for people of all income, social, and ethnic origins. To do so, we must first honestly confront our past and recognize that the systems we built in the 1950s and 1960s failed us not only because they created physically dysfunctional places but just as much because of the built-in biases that have disenfranchised racial minorities and poor people. If we can understand this history, we will be better able to identify the structural biases that are inherent to our systems of designing, financing, and constructing transportation infrastructure and communities. In doing so, we might be able to develop meaningful solutions that empower us to create communities that are equitable, inclusive, and sustainable.

NOTES

1 H. Ahangari, C. Atkinson-Palombo, and N. W. Garrick, "Assessing the Determinants of Changes in Traffic Fatalities in Developed Countries," *Transportation Research Record* 2513 (2015): 63–71; P. Newman and J. Kenworthy, *Sustainability and Cities: Overcoming Automobile Dependence* (Washington, DC: Island Press, 1999).

2 T. Litman, "Evaluating Transportation Equity: Guidance for Incorporating Distributional Impacts in Transportation Planning," *World Transport Policy and Practice* 8, no. 2 (2002): 50–65, https://doi.org/www.vtpi.org/equity.pdf; W. E. Marshall and N. N. Ferenchak, "Assessing Equity and Urban/Rural Road Safety Disparities in the US," *Journal of Urbanism* 10, no. 4 (2017): 422–441, https://doi.org/10.1080/17549175.2017.1310748; T. Gantz, E. J. De La Garza, D. R. Ragland, and L. Cohen, "Traffic Safety in Communities of Color" (research report, eScholarship Repository, University of California, 2003), http://repositories.cdlib.org/its/tsc/UCB-TSC-RR-2003-05.

3 S. Phillips, "Unaffordable Housing Sucks, but the Money We Waste on Transportation Is Still the Biggest Problem," *Better Institutions* (blog), accessed March 31, 2019, http://www.betterinstitutions.com/blog/2014/05/unaffordable-housing-sucks-but-money-we.

4 J. Zheng, C. Atkinson-Palombo, C. McCahill, R. O'Hara, and N. W. Garrick, "Quantifying the Economic Domain of Transportation Sustainability," *Transportation Research Record* 2242 (2011): 19–28.

5 K. A. Floberg, "Change in Urban Fabric through Space and Time at Differing Levels of Automobility" (master's thesis, University of Connecticut, 2016); B. R. Blanc, M. Gangi, C. Atkinson-Palombo, C. McCahill, and N. W. Garrick, "Effects of Urban Fabric Changes on Real Estate Property Tax Revenue: Evidence from Six American Cities," *Transportation Research Record* 2453 (2014): 145–152; N. C. Olinski, N. W. Garrick, and C. Atkinson-Palombo, "Stamford, Connecticut: From Traditional Downtown to Edge City" (paper presented at the Transportation Research Board 95th Annual Meeting, Washington, DC, 2016); A. Polinski, "Transit Era Hartford: Using the Past to Plan the Future" (master's thesis, University of Connecticut, 2015).

6 M. Fullilove, *Root Shock: How Tearing Up City Neighborhoods Hurts America, and What We Can Do about It* (New York: New Village Press, 2016).

7 J. Jacobs, *Dark Age Ahead* (New York: Vintage Books, 2005).

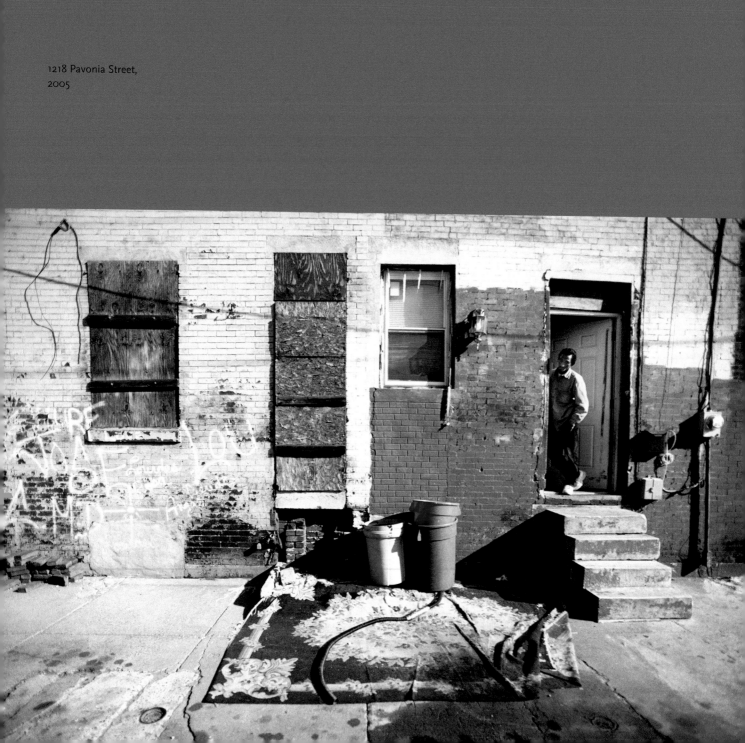

1218 Pavonia Street,
2005

NO. 2 Dignity in an Era of Financialization

ANTHONY S. ALVAREZ

S ince the early 1980s, the importance of consumer access to credit has increased dramatically. More than ever, having access to banking and credit is central to making ends meet. Unfortunately, we increasingly have a two-tiered system. In one, banks and other financial services providers help manage money and foster wealth accumulation. In the other, banks begrudgingly provide services, but with hefty fees. Even when these services are "low-cost," their rules and conditions lend themselves to making mistakes, and heavy fees await each delay or misstep.

No service speaks to this dynamic like payday loans—high-fee, short-term loans that borrowers are expected to pay back on their next payday, typically in two weeks. Borrowers pay dearly for such loans, as fees are typically fifteen dollars for every hundred dollars borrowed. When calculated on an annual basis, the annualized percentage rate is over 300 percent. In many states, there are more payday lenders than McDonald's or Starbucks; in others, there are more payday lenders than McDonald's or Starbucks *combined*.[1] The increasing prevalence of payday lenders has led to concerns over their predatory practices, which take advantage of the most financially vulnerable.

While many forms of alternative credit have grown up over this time, payday loans have received the most scrutiny. This is primarily because the structure of payday loans, with their quick payback period and high costs, leads to more borrowing—often called "debt spirals" or "debt traps." A study by the Consumer Finance Protection Bureau (CFPB) tells the story.[2] Using data provided by banks and lenders, the CFPB found that only 13 percent of borrowers took out one or two loans, and that this group accounted for 2 percent of all fees collected. A whopping 48 percent took out at least eleven loans over twelve months, and this group accounted

for 75 percent of all fees collected. Thus, while payday lenders may not charge excessive prices, their business model is built on getting repeat customers, as this is where lenders generate the bulk of their revenues. In fact, the *median* borrower in the CFPB study took out ten payday loans over twelve months, generating $458 in fees. Twenty-five percent of customers paid $780 or more in fees over the twelve months of the study. This suggests that if payday loans are used as needed—a quick, short-term bridge loan to cover unexpected expenses—the payday loan industry would generate less income and therefore be less profitable.

This credit system must be contextualized by long-term trends in employment and wages. Employment relationships have become more tenuous, with Americans no longer keeping a single job with a large corporation over the course of their lives. Among lower- and middle-income groups, job switching is especially frequent, and even stable employment brings variable schedules and pay. We have seen the rise of a "gig economy," where workers have second jobs such as driving for Uber or Lyft, to supplement their income. For some, gig work is the *only* source of income.

This is why the credit system is so important—if income can vary from week to week and month to month or is dependent on your car being in good working order, what happens when an unexpected emergency arises? A large percentage of Americans say they cannot cover even small budgetary shortfalls of $400 out of their savings alone. In a properly functioning financial system, credit options would be available to help people bridge these gaps. Instead, a sizable portion of the US population is either unbanked, underbanked, or credit invisible. In other words, many Americans do not have access to mainstream financial institutions to help them navigate the ups and downs of their budgets.

Even when these services are available, the cost of access is high. This is the downside of having low income and, as a consequence, low account balances—the terms for being a part of the financial "mainstream" can be a source of financial strain itself! It is not unusual for people of color to experience predatory inclusion, where they are exposed to high fees when provided services that are available to everyone else.[3] Whether it is bank accounts, student loans, or auto loans,

sometimes being included can be expensive.[4] From this perspective, the financial system operates as a means by which economic inequalities are reproduced—where, if you are a person of color with low to moderate income, financial institutions may actively make your financial life harder, rather than easier.

FIELD MARKINGS

The photograph shows what appear to be row houses. On the left, the row house is vacant, with boarded-up windows, spray-painted scrawl, and masonry in need of repair. On the right is another row house, the window frame needing repair but functional, and a porch light with a bulb in it. The house seems lived in and functional, including patches into the power infrastructure on the right-hand side. The man standing in the doorway to the house has the air of someone contemplating plans. The small flight of steps leading to the door is clear of debris, and there is little trash on the street other than a lone paper in the shadow of the steps. There is no graffiti on this house, again lending the feeling that someone has cared for it to the best of their ability.

The photo is a study in contrasts—at once an image of neglect and dignified attention; an image of "giving up" and yet also an image of persistence. Housing and property make up the vast majority of wealth for most Americans, and thus at first blush the neglect depicted here suggests wealth squandered. However, that first impression is shortsighted, as the man stands in a home still tended, plugged into the infrastructure, attempting to continue moving forward, living with the dignity he can muster. He is adapting, persisting, and doing the best that he can, making use of the resources available to him—though the system has forgotten about him. Because what we really see is an image of a community that has been starved from the seed corn, the *capital*, that it needs in order to prosper, and yet it still manages to move forward, to persevere. Lower-income Black and Brown communities like we see in this photo

frequently do not have the option to use property as an asset to open the door to credit markets. The options they *do* have are alternative financial institutions such as pawnshops, title loans, and, most perniciously, payday loans.

Place, Space . . . and Time

Like all photos, this image does not simply capture a moment in time, but rather contains within it markings of the past. The genius of the photo is that the forces that produced this moment are as visible as the man standing on his stoop. The photo is an illustration of the results of America's long history of redlining—of keeping people of color *in their place*—and of their exclusion from, or at best predatory inclusion in, credit markets. These populations have been segmented into specific neighborhoods and communities, and then abandoned as work and credit disappeared. But to properly understand this dynamic, we must return to the past, the 1960s in particular.

By 1968, the civil rights movement had made considerable gains even if it faced an uncertain future—the passage of the Civil Rights Act of 1968 was a major step forward and included antidiscrimination regulations for housing (the Fair Housing Act). But Richard Nixon's election pushed the agenda in a new direction. Nixon moved away from using the power of the state to deconstruct the policies and attitudes that brought about segregated urban communities in the first place. Instead, he moved toward *market-oriented* solutions he termed "Black capitalism."[5] Thus, the very people who had been working under segregated poverty's yoke were now expected to solve it, without control over their own institutions or meaningful assistance from the federal government. Nixon succeeded politically in characterizing more active efforts to help Black communities as handouts that created "dependency," while he claimed to be interested in providing a "hand up," allowing Blacks to live with "dignity."[6] This focus allowed the political establishment to say it was doing something, while in fact it was promoting ineffectual market-oriented policies and ignoring the long history of Black and Brown communities that had been providing their own "hand up"

for generations, who had already earned their dignity (and then some). By the early 1970s, there had been no large increase in bank investment in Black communities, though a small increase in Black-owned banks did briefly emerge and then fail after having difficulty maintaining profitability.[7] Over the next decade, regulatory efforts aimed at credit markets were passed—the Fair Housing Act of 1968, the Equal Credit Opportunity Act of 1974, the Home Mortgage Disclosure Act of 1975, and, perhaps most important, the Community Reinvestment Act of 1975—but the effectiveness of these tools was always a by-product of the administration that wielded them. By the early 1980s, the neoliberal era, presaged by Nixon's Black capitalism, had begun.

FIELD NOTES

Returning to the photo, this context provides another lens through which to view this home, this man, and his efforts. He is a resident of an urban community that had faced segregation, White flight, and abandoned properties, draining Black communities of their asset values and leaving them little with which to secure long-term loans. Faced with low-paying, insecure wages and jobs moving to the suburbs, he finds dignity making the best use of what he has. One can imagine many and varied policy responses to help deal with financial precarity and hard-to-access credit markets. But what emerged were payday loans—an opportunity to profit from the vulnerability of the financial lives of consumers. The loans' high costs and onerous terms were justified by those same consumers' vulnerability. And what began as small-scale financial institutions spread through Black and Latino neighborhoods, making their way into working- and middle-class communities of color, and became big business.[8] The relationship between mainstream banks and payday lenders has also raised concerns. Mainstream banks, rather than taking the opportunity to provide credit to communities that need it, have instead elected to lend their operating licenses to payday lenders. While this has brought the banks

increased regulatory scrutiny, it has provided both banks and payday lenders with strong financial returns.[9]

The juxtaposition of the two homes in the photograph, one boarded up and the other still cared for, illustrates the complexity of the relationships within the community. A consequence of a lack of healthy financial alternatives has been that people often rely on friends and family for financial help. But this use of monetary support can come at a cost, given that many members of our networks face similar situations. We know that sometimes the desire to help family members can actually lower the availability of financial resources within already-struggling families, thus increasing financial burden within networks and widening the racial wealth gap.[10]

However, the networks and relationships that these communities have come to rely on may prove to be one way forward. One innovative project in San Francisco, the Mission Asset Fund (MAF) has used *tandas*, or lending circles, to provide capital, emergency savings, and positive credit marks. Lending circles are forced savings mechanisms, common in many cultures, in which participants contribute monthly to a pot of money, with a different member receiving the pot each month on a rotating schedule. Traditionally, these arrangements have been informal and unacknowledged by mainstream financial institutions. However, MAF has arranged to have these activities acknowledged as financially responsible behavior, thus making visible the dignity and responsibility of these communities to banks and credit agencies.

A properly functioning credit system would have recognized the dignity evident in this photo and provided capital to maintain financial stability for individuals in communities such as these. Fred Wherry, Kristin Seefeldt, and Anthony S. Alvarez propose a redefinition of financial citizenship based on the model that MAF is employing in San Francisco.[11] This includes a right to be free from exploitation, a right to respect, a right to belong, and a right to cocreate institutions of commerce such as lending circles. In the 1960s, Nixon had promoted Black capitalism without providing (and in fact actively denying) Black communities control over the institutions that influenced their lives. A financial citizenship for the twenty-first century would open these institutions to redefinition, bringing them closer to the lived realities of Black and Brown communities.

NOTES

1 Lisa Servon, *The Unbanking of America* (New York: Mariner Books, 2018).

2 Consumer Finance Protection Bureau, "Payday Loans and Deposit Advance Products," CFPB white paper, 2013, https://files.consumerfinance.gov/f/201304_cfpb_payday-dap -whitepaper.pdf.

3 Louise Seamster and Raphael Charron-Chenier, "Predatory Inclusion and Education Debt: Rethinking the Racial Wealth Gap," *Social Currents* 4, no. 3 (2017): 199–207.

4 Devin Fergus, *Land of the Fee: Hidden Costs and the Decline of the American Middle Class* (New York: Oxford University Press, 2018).

5 Mehrsa Baradaran, *The Color of Money: Black Banks and the Racial Wealth Gap* (Cambridge, MA: Belknap Press, 2017).

6 Baradaran, *Color of Money*, 177–178.

7 Baradaran, 187–204.

8 Christopher S. Fowler, Jane K. Cover, and Rachel Gershick Kleit, "The Geography of Fringe Banking," *Journal of Regional Science* 54, no. 4 (2014): 688–710.

9 Karen Richardson, "Moving the Market—Tracking the Numbers/Street Sleuth: Investors Rethink 'Payday Lending'; Practice of Making Loans with Paycheck as Collateral Comes under Scrutiny," *Wall Street Journal*, February 17, 2005, C3.

10 Tatjana Meschede, William Darity Jr., and Darrick Hamilton, "Financial Resources in Kinship and Social Networks: Flow and Relationship to Household Wealth by Race and Ethnicity among Boston Residents," Federal Reserve Bank of Boston, Community Development Discussion Paper, 2015.

11 Fred Wherry, Kristin Seefeldt, and Anthony S. Alvarez, *Credit Where It's Due: Rethinking Financial Citizenship* (New York: Russell Sage Foundation, 2019).

Gordon Terrace,
east of Broadway,
2004

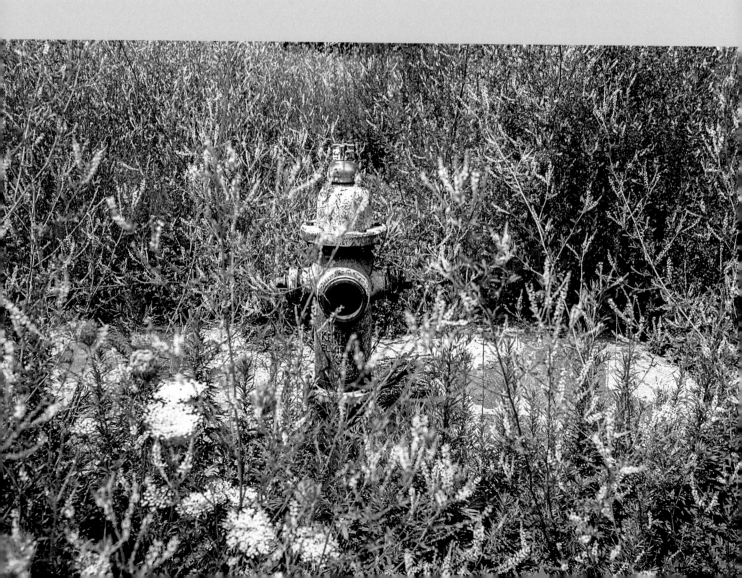

NO. 3 The Inequitable Erosion of Hospital Care

ALECIA J. MCGREGOR

Hospitals are an indispensable part of U.S. health care. Their proximity is vital when a family member has a stroke, a child goes into anaphylactic shock, or a person whose pregnancy is considered high risk requires an emergency C-section. As institutions, American hospitals originated as organizations with a distinctly social role: to provide care for the poor, the physically sick, and the mentally ill. Why, then, are contemporary hospitals leaving the communities that need them most?

Between 1999 and 2014, nearly 600—or about 10 percent of all—U.S. hospitals closed their doors, resulting in a massive reduction in access to acute care nationwide.[1] Across the country, small and medium-sized hospitals, for-profit hospitals, and those in inner-city and rural locales were more likely to crumble than larger facilities in well-to-do suburbs. In February 2018, the *Wall Street Journal* highlighted this ongoing "full-service fade" in hospital care, which gives way to a scaled-back assortment of outpatient services in place of comprehensive inpatient care.[2] This removal of acute care disproportionately strikes rural communities as well as inner cities—many of which are now postindustrial zones of heightened poverty and unemployment.

However, the gross maldistribution of hospital care did not arise in a vacuum. The geography of hospital closure in the United States is often an artifact of unequal economic disinvestment, White flight, and our class-based hospital payment system that renders some patients and procedures more profitable than others. The mid-twentieth-century exodus of industry

from northeastern urban centers—many of which became majority people of color and poor—preceded a shift in the distribution of hospital resources that also falls along racial lines and constitutes a glaring example of institutionalized racism in the U.S. health-care system.

Postindustrial New Jersey is instructive as a case to understand the astonishing national loss of hospitals and the unequal wreckage left behind by their closure. According to the New Jersey Hospital Association, twenty-six acute care hospitals closed their doors between 1992 and 2014. Between 2000 and 2014, the percentage of Black residents in a state legislative district was positively correlated with the risk of hospital closures in that district. Although the rapid rate of closures has been more dramatic in New Jersey than in neighboring states, the pattern in New Jersey mirrors what is occurring nationally. All across the country, urban hospitals are significantly more likely to close in Black neighborhoods than in other areas, giving rise to a phenomenon called "medical deserts."[3] A partial policy analysis might argue that this disparity merely reflects the fact that Black residents are more likely to be poor and uninsured, making them less likely to provide reimbursable care to hospitals. That is, the problem is all economics, and hospitals are simply safeguarding their bottom lines.

It is true that a patient's insurance type determines how much hospitals are paid for his or her care; Medicaid reimburses substantially less for most procedures than do Medicare and commercial insurance. Still, Alan Sager has shown that hospital closings between 1936 and 2010 were less a function of hospital financials than neighborhood racial composition.[4] In his analysis, smaller hospital size and a greater percentage of Black residents in the surrounding area were stronger predictors of closures than a hospital's operating margin. Hospital efficiency did not matter. Although Title VI of the 1964 Civil Rights Act explicitly prohibits segregation in hospitals, a de facto "segregation" of hospitals exists in many urban areas (across race, class, and insurance status). In the absence of adequate checks on an overwhelmingly private hospital market, hospitals in the most disadvantaged areas can close without penalty to themselves—though while imposing substantial harm on their former patients.

Against a backdrop of entrenched racial residential segregation and concentrated poverty, racial disparities in where hospitals close further exacerbate the unequal pattern of resource distribution in New Jersey. New Jersey is one of the most highly segregated states in the nation—its school system ranks sixth in Black-White segregation.[5] Black New Jersey residents are disproportionately concentrated in and near postindustrial cities such as Newark and Trenton—cities with poverty rates of 28 percent each between 2014 and 2018—and Camden, which had a poverty rate of 37 percent in the same time period.[6] Yet, lifesaving resources in these locales have been steadily discarded.

FIELD MARKINGS

Vergara's image of a rusted fire hydrant in an overgrown, abandoned lot typifies the landscape of intentional urban neglect in America. The lot is filled with grass and flowering weeds, interspersed between gravel and concrete. Yet, the vacuous image evokes more questions about what is *not* in the photograph than about what is visible. In fact, the desolate field does not reflect the dense vibrancy of urban America. If we were not informed in advance that this was taken in Camden, one could not be sure whether it had been taken in Appalachia, rural Vermont, or elsewhere. Where is evidence of "the city" in this picture?

One message, however, is clear from the height of the greenery and the aged discoloration of the hydrant: maintenance and care are long overdue. In the case of the lonely hydrant, what was once a precious, lifesaving resource is no longer in use—whether or not individuals still live and work in the vicinity. In this way, it is emblematic of what happens when a community loses an acute care facility. The scene parallels the empty lots and abandoned facilities, where medical staff and clinicians once hurried through hospital wards to treat thousands of patients each year.

The growing void of vital community resources in poor neighborhoods is a ubiquitous marker of widening inequality in America. For example, in the late 1960s and 1970s, Black neighborhoods in New York City lost fire infrastructure, including hundreds of fire hydrants throughout the city that became dormant.[7] Fire hydrants, as a social service, serve a protective role in communities, provided they produce adequate water pressure and are close enough to dwelling places. As with hospitals, when disaster strikes and homes go up in flames, hydrants are necessary to put out fires and save lives. Moreover, in a city famous for sweltering summertime heat waves (triggering a seasonal rise in heat stroke), the loss of hydrants could exacerbate the public health hazard of rising temperatures. As is also the case with hospitals, when these structures are removed—or left to deteriorate—their loss creates ripple effects on the local economy.

As it turns out, the image of the defunct hydrant was taken on Gordon Terrace, east of Broadway, less than two miles away from the site of a former hospital. In 2001, Camden lost an over 200-bed full-service hospital that had offered inpatient and emergency care. Vendors that were in proximity of the hospital, like Hospital Central Services, a company that provided laundry services, later closed in 2017, resulting in the loss of eighty-one local jobs.

Several events from the last sixty years help tell the story of why many urban landscapes are becoming desolate, like Vergara's image, and why hospitals are closing. In fact, the discontinuation of hospital services in city centers is the logical outcome of decades of harmful economic disinvestment from northeastern cities, following the Great Migration of African Americans from the South to the North. White flight from the cities to the suburbs in the mid-twentieth century co-occurred with the active departure of services, businesses, and capital from postindustrial city centers. For example, between 1940 and 1980, the populations of Trenton and Newark decreased 26 percent (from 124,000 to 92,000) and 23 percent (from 430,000 to 329,000), respectively.[8] The departure of people and industry was accompanied by the elimination of services, including health care. Insidiously, the loss of health care further propels a cycle of the loss of commerce that locks this destructive pattern of erosion of care in place.

FIELD NOTES

What happens in the aftermath of hospital closures, and what are their implications for the overall health of communities? Importantly, can neighborhoods already struggling with disinvestment and unemployment make use of these empty structures?

Turning again to New Jersey, the last full-service maternity ward in Trenton closed its doors in 2011. Capital Health, the company that controlled the old hospital, framed the obstetric unit closure as a relocation and redirected patients and some employees to Capital Health's newly constructed Hopewell campus.[9] The racial difference between the old and new locations could not be more dramatic: the abandoned Bellevue Avenue facility is located in a census tract that was approximately 90 percent Black, while the pristine Hopewell campus sits on one that is 93 percent White. Moreover, there are no public transit routes between the old hospital location and the new one, presenting an additional hardship for patients and hospital employees who may not own reliable vehicles. Now, the former hospital remains unoccupied. As the *New York Times* reported in 2014, the facility was initially sold to an entrepreneur who sought to turn it into a for-profit medical mall, but that business endeavor has since been abandoned.[10]

Similarly, several closed hospitals in New Jersey have been converted to medical arts complexes that often prioritize medical services that are highly reimbursed, such as dialysis and outpatient surgery. For example, Community Healthcare Associates, a company that specializes in converting vacant hospitals into alternative medical facilities, adapted Muhlenberg Hospital and Barnert Hospital (both of which closed in 2008) into the Muhlenberg and Barnert medical arts complexes. Although some outpatient clinical services will remain at these sites, the permanent removal of inpatient care leaves a crucial gap in the continuum of care services. The occupants of medical arts complexes do not adequately substitute the role of full-service, mission-driven hospitals in low-income communities. Although some new occupants may be nonprofit, they are not obligated to provide charity care as hospitals are. Additionally, they are not required to demonstrate community benefit through the completion of regular Community Health Needs

Assessments, as federal law requires of nonprofit hospitals in exchange for their tax exemption.[11] As a result, many services at medical malls remain out of reach for surrounding communities. For example, the care now available at Barnert is limited to outpatient services like urgent care, ambulatory surgery and diagnostics, drug rehabilitation, and other care.

Nevertheless, several blueprints to repurpose empty hospital buildings have emerged across the country. For example, the 2,000-bed Charity Hospital on Tulane Avenue in New Orleans was forced to close in the wake of Hurricane Katrina in 2005. After a raucous debate, and dubious maneuvers on the local, state, and federal levels, efforts to open a new Louisiana State University teaching hospital ensued, and the towering Charity building was left empty. As its name implies, Charity, by and large, served the most vulnerable populations in New Orleans—almost 75 percent of its patients were African American, and 85 percent earned less than $20,000 per year.[12] The state spent years searching for bidders to redevelop the space. As of late 2018, the redevelopment contract had been awarded to an Israeli real estate development firm and a New Orleans–based developer, and news outlets predict that the property will be used for mixed residential and commercial purposes.

In Michigan, Southwest Detroit Hospital has been closed since 2007 and is slated for "mixed-use development" in 2020. In southeast Washington, DC, the District of Columbia General Hospital closed in 2001, leaving behind a sprawling mostly empty campus, across the site from the district jail. Although the site had been used to house the homeless for more than a decade, DC mayor Muriel Bowser has closed the large family shelter and plans to demolish the structure.

When it comes to redeveloping former hospitals, deep inequities persist in the reuse of closed facilities. Researchers at the University of North Carolina at Chapel Hill found that in Black rural neighborhoods, closed hospitals were less likely to be converted to other medical services than was the case in White neighborhoods. Instead, shuttered hospitals in communities of color were more likely to be subsequently used for nonhealth reasons, such as high-end apartment buildings. With the buildings of former safety-net hospitals being sold to the highest corporate bidder, how can we ensure that necessary services are equally distributed in American communities?

Indeed, the centrality of private markets in our health-care system is a chief enabler of hospital closures and the persistent inequalities they reinforce. After all, markets aim to maximize efficiency, not equity. In our current historical moment, hospitals, as businesses, behave much like many other American businesses—making decisions to improve their profitability and reach a desirable market. As gigantic mergers occur in media, agribusiness, and elsewhere, the suppliers of health care adopt similar strategies to increase their market share and their latitude to set higher prices and reach a wider patient pool. A 2017 study by the Commonwealth Fund estimated that by 2016, 90 percent of all metropolitan areas had highly concentrated hospital markets, meaning that a large portion of hospital care was owned by only a handful of large companies.[13]

The Affordable Care Act (ACA), also known as Obamacare, builds upon our market-based system and, in some unexpected ways, exaggerates the adverse tendencies of the health-care market. Ironically, the ACA was passed with the clear objective to *increase* health-care access, yet it is commonly identified as a cause of growing consolidation in the health-care market. Payment reforms included in the ACA, such as Accountable Care Organizations (ACOs), incentivize hospitals and other providers to create larger patient pools, which in practice frequently is achieved by way of consolidation. As hospital systems integrate and become more powerful, affiliated hospitals that take on a disproportionate share of low-income Medicaid or uninsured patients are often first on the chopping block. When services in disadvantaged neighborhoods are deemed duplicative, health systems cut costs by closing locations, often regardless of the unequal geographic impacts they may have. Inadvertently, the race to create ACOs seems to have further eroded access for communities that cannot bear the higher price of consolidation.

As the growth of big hospital systems chips away at the viability of small community hospitals, for-profit hospitals have begun to eclipse nonprofit and public hospitals and the social mission they serve. For example, the proportion of for-profit hospitals in New Jersey surged from only 2.5 percent of all hospitals in 1999 to 24 percent of all hospitals in 2017.[14] As nonprofit, independent community hospitals, as well as public hospitals, diminish in number, so does the strength of the social mission that drives them. The Internal Revenue Service mandates that hospitals with

501(c)(3) status provide benefits to their surrounding communities in exchange for their tax-exempt status. Whether nonprofit hospital systems meaningfully meet this requirement—in proportion to the revenues they receive and the local taxes they never pay—remains in question.

Regardless of how you look at it, the future of hospitals in low-income communities is in a precarious state. As debates ensue over Medicare for All, modifying the Affordable Care Act, or pursuing even more market-based alternatives, it is crucial to enforce regulations to rein in the inequitable trend in hospital closures. Policy makers must reckon with the ways that entrenched social inequalities—racial residential segregation, concentrated poverty, and unequal access to quality health care—have been exacerbated under current market-based policy designs, where hospitals are able to exit communities in search of greener pastures, leaving populations in dire need. When it comes to the dearth of resources, education, and employment, many American communities are already on fire. By addressing the unequal impact of hospital closures, we can take the first step to extinguishing the crisis.

NOTES

I would like to acknowledge N. Kofi Addo for his generous comments and editorial assistance throughout this process.

1 American Hospital Association, AHA Annual Survey Database (1999 to 2014), accessed May 10, 2015, https://www.ahadata.com/aha-annual-survey-database.

2 L. Landro, "What the Hospitals of the Future Look Like," *Wall Street Journal*, accessed March 15, 2018, http://wsj.com/articles/what-the-hospitals-of-the-future-look-like-1519614660.

3 A. Kilkenny, "NYC's Disappearing Neighborhood Hospitals," *The Nation*, August 19, 2013, https://www.thenation.com/article/nycs-disappearing-neighborhood-hospitals/.

4 WBUR, "Causes and Consequences of Urban Hospital Closings and Reconfigurations: 1936–2010," WBUR Boston University World of Ideas, April 14, 2013, https://www.wbur.org/worldofideas/2013/04/14/sager.

5 Civil Rights Project, "New Jersey's Segregated Schools: Trends and Paths Forward," UCLA, 2017, accessed March 25, 2019, https://www.civilrightsproject.ucla.edu/research /k-12-education/integration-and-diversity/new-jerseys-segregated-schools-trends-and -paths-forward/New-Jersey-report-final-110917.pdf.

6 U.S. Census Bureau, "Quick Facts," accessed March 25, 2019, https://www.census.gov /quickfacts/.

7 J. Flood, "Why the Bronx Burned," *New York Post*, May 16, 2010, https://nypost.com /2010/05/16/why-the-bronx-burned/.

8 New Jersey State Data Center, "New Jersey Population Trends 1790 to 2000," 2001, accessed March 25, 2019, https://www.state.nj.us/labor/lpa/census/2kpub/njsdcp3.pdf.

9 The health system temporarily operated a smaller perinatal center at its other Trenton hospital site between 2011 and 2014. E. Duffy, "Capital Health Seeks to Shut Down Trenton NICU," *Times of Trenton*, accessed December 15, 2020, https://www.nj.com/mercer/2012 /06/capital_health_seeks_to_shut_d.html.

10 At the time of this writing, the former Mercer Hospital building was still in need of a buyer. R. Kaysen, "Repurposing Closed Hospitals as For-Profit Medical Malls," *New York Times*, March 4, 2014, http://www.nytimes.com/2014/03/05/realestate /commercial/repurposing-closed-hospitals-as-for-profit-medical-malls.html.

11 Kaysen, "Repurposing Closed Hospitals."

12 R. Rudowitz, D. Rowland, and A. Shartzer, "Health Care in New Orleans before and after Hurricane Katrina," *Health Affairs* 25, no. 5 (2006): w393–w406.

13 B. D. Fulton, "Health Care Market Concentration Trends in the United States: Evidence and Policy Responses," *Health Affairs* 36, no. 9 (2017): 1530–1538.

14 Kaiser Family Foundation, "Hospitals by Ownership Type," 2019, accessed March 25, 2019, https://www.kff.org/other/state-indicator/hospitals-by-ownership.

SYMBOLS AND SENTIMENTS

116 Linden Street,
2006

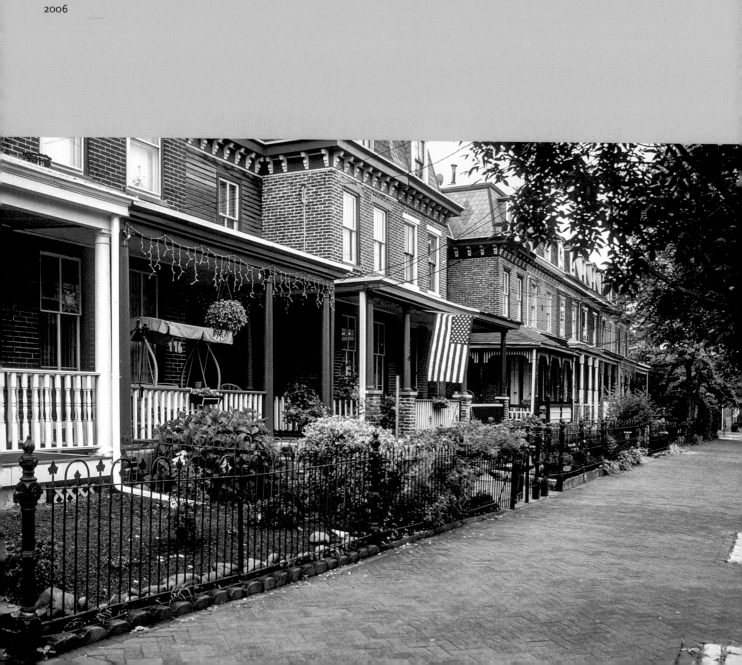

NO. 4 Building Codes: Built Elements of the Housing Landscape

ZAIRE Z. DINZEY-FLORES

A house complete with picket fence is a highly celebrated element of the Americana landscape. Through their architectural details, most readily visible in a street-facing facade, generations of housing types—from row houses to suburban single-family homes—insinuate the lives and livelihoods deemed proper in the national imaginary. Most assume that residential properties' physical characteristics are neutral, or at least universal. A home is deemed "nice" and "desirable" by seemingly impartial characteristics such as the number of bedrooms and bathrooms, layout, design, and style.

Houses, however, are never socially neutral landscapes. They are representations, reflectors, and refractors of our society. At the heart of a person's social universe, the house has the power to image the lives and lifestyles of its inhabitants and figures prominently in how people think of themselves. Houses become an extension of the self, an appendage to the body to the point that where you live informs not only the people you live with, the school your children may attend, but also who you are. Housing is an especially powerful symbol of race and class in the United States, with aesthetics and location playing prominent roles as containers and reproducers of social inequality.[1] That housing policies and discriminatory real estate practices have been central to opportunity in the United States is widely discussed in the literature. Practices such as redlining, blockbusting, enforced racial segregation, and subprime mortgage lending have systematically enforced racial and class orders.

However, less well articulated are generalized approaches to reading and experiencing the home, and the ways in which using the home as the vessel for the realization of the American dream reinforces inequality. The housing built environment often becomes a reliable site to mask racial and class antipathies and racist practices. Houses are laden with the significations and social productions that, under the aegis of costumer demands and buyer preferences, are assigned social worth. The front of a house carries considerable weight in articulating a place, its people, and its value. The front facade dialectically syncs the social to the built environment by making legible not only a neighborhood and its qualities but also the characteristics and lifestyles of the inhabitants. Practices as diverse as pricing real estate, assessing safety and threat risks, policing, expressing personal aesthetics and design preferences, making political statements, playing, conforming to socially desirable behavior, enforcing legal norms of comportment, neighboring, and casual socializing all engage the front of the house. The curb, thus, becomes a reflection of you: Do you take good care of your environment? Are you good with gardens? Are you messy? Do you like to spend time outside?

While sometimes there is reliable information about who resides in certain areas, residential choices and practices are often veiled by symbols of "beauty" and "safety," which have been elaborated along racial scripts. In this way, apart from the inequities written into housing markets and associated opportunity (e.g., school districts), the visual characteristics, aesthetics, and vernacular qualities of the American "dream home" act as a reproducer of inequality. Unmasking the qualities that deem a home "nice" and "worthy" shows where exactly the built environmental reproducers of inequality in the housing landscape—those objects imbued with and produced by social histories that make them socially prized and relevant—are to be found.

In the following I take apart and detail the built elements that code the housing landscape, as shown in Vergara's image. The field markings, the built objects, and the forms in the photograph symbolically compose and codify the material value of place.

FIELD MARKINGS

Vergara's image depicts a strip of a block face of a Camden neighborhood many would consider quaint. What makes it so? The composite photographic frame evokes an urban version of the American dream of the white picket fence—here as brick homes with well-appointed front yards and well-maintained sidewalks. What elements make this scene pleasing? What marks it as the American dream? How do the elements of the houses in the picture circulate and deal in race and class inequality?

Location

Where a house is located is one of the prime markers of its condition. The place, neighborhood, town, city, and context of a house are among the first markers of the social value of a home. The location of a home is believed to encapsulate the full scope of the quality of life to be derived from the home. The row houses in Vergara's picture were built at the turn of the nineteenth to twentieth century in Camden, New Jersey. Part of the Philadelphia metro region, Camden is a small city surrounded by inner- and outer-ring suburbs. The city has experienced the typical journey of metropolitan deindustrialization. Through deindustrialization, sectors of Camden near the center were marked by disinvestment and decay.[2] Segregated settlement patterns attuned to the racial climate of the twentieth century created a racial and economic cartography that placed White communities in suburban areas. Through the twentieth century, these suburban communities tried to separate and distinguish themselves from the central areas of Camden, which were marked as decaying, and worked hard to ward off what a newspaper article called the fast-spreading "Camden syndrome." Ultimately, Camden represents the combative, even traumatic, history of American institutionalization of race at the level of the

built environment, one that obtusely erected an urban/suburban divide. In Camden, a central city location in an area inhabited by people of color obfuscates many of a house's other characteristics and marks it as socially undesirable. Vergara's pristine, neighborly street with tended gardens fades at the positioning of the map. In this zip code, which has a median real estate price that is well below the U.S. median, this Camden home and its urban location insinuate the spotty racial history of the city. No amount of upkeep, of pristine gardens, of well-kept structures of the home and neighborhood can offset the city of Camden's low racialized value, particularly in its relation to a valued "White" suburb.

Early Suburban Homes

Row houses were built in the United States starting at the turn of the century. These particular semidetached buildings in Vergara's photo were built in 1890. At that time, they were a step up from the tenements that characterized northeastern cities. But as the city grew around them, and a racial cartography of an inner Black city relative to a White suburb took hold, houses like these were demoted as obsolete by later generations of detached housing in big-box suburbia. Even if they were considered quaint, especially when well-kept, their desirability as representations of the American dream waned for most of the later part of the twentieth century, especially informed by their location close to the "inner city" in the inner rungs of the suburbs. Since the twenty-first century entered, these row houses have experienced a "revival," a resurrection of sorts harkening back to the days of their construction, fueled by gentrifiers returning to the central city.

Porches

Research has shown that porches have deep cultural significance for Latinos and Blacks in the United States.[3] In porches, African Americans have created a space for gatherings and

neighboring—a place for important storytelling and interfacing with history.[4] Latinos in LA have transformed the front yard into a particular vernacular style that creates an adapted plaza in front of the house, melding the private space with public space to create a social dialogue.[5] Porches thus codify racial practices and align ideas of use with those of community, allocating value in the process.

Fences

Picket fences are the hallmark of the realization suburban dreams and middle-classness. But, as I have shown in other work, fences have been used for many reasons, with the objective to keep in and out, signal private space and the limits of a territory, and mark those who belong.[6] White picket fences promised shelter from the rowdy city, a place of respite and leisure. Mary Pattillo-McCoy shifts our understanding of picket fences and reveals an alternate experience of Blacks in trying to attain the security that the suburbs promised to Whites.[7] She finds that Black picket fences come with a different set of realities, with privileges encapsulated in perils and instabilities not apparent in white picket fence experiences. Black picket fences version of suburbia resulted in a different experience for Blacks, one met by resistance to their presence, blockbusting, segregation, and rejection. Indeed, Black middle-classness and its markers (house and car) have always been characterized by deep insecurity.[8]

But the fences in Vergara's photo are wrought iron and should not be overlooked. They recall the industrializing period and signal the moment before housing entered the American popular sphere as a commodity—that is, when housing turned from being a shelter to a mass-produced object destined for the market. Desirability and value thus are constituted by the very materials, the form and shape, and the respective social meanings of the physical qualities in housing construction.[9] Ornate, expensive, handmade ironwork stops being part of the ingredients of a suburban housing boom. Houses like these are left to communities of color in

processes of racial succession. Residents of color end up being the residents of ornate but forgotten housing forms, as Whites' preferences turn them away from these types of housing to larger unattached single-family homes in suburban tracts suitable for automobiles. The trend foreshadowed a more recent era, when the city again has been donned with the possibilities of delivering an adequate American dream. As the privileged return to the city, they find the long-devalued "original details" unintentionally preferred by forgotten communities of color. As preferred symbols of civilization and privilege were recast from Victorian excess to sparse and "clean" modernity, communities of color rode the wave of aesthetic preferences that repeatedly placed them, their houses, and their wares on the devalued side of aesthetic hierarchies.

Sidewalks

Much space has been dedicated to the function of the sidewalk in urban life. In her seminal book, Jane Jacobs highlights the sidewalk as the place where city dwellers encounter each other.[10] For Jacobs, the sidewalk is the place where natural territoriality happens and people keep their eyes on the street and each other. Annette Kim ethnographically analyzes the sidewalk as a particular type of public space with its own set of structured social relations. At times approximating a park, the sidewalk is socially constructed by its multiple users and social systems.[11] In its promise of a community life, the sidewalk figures prominently in the conception of urban life—a place to encounter others in the same classical way that W.E.B. Du Bois, Georg Simmel, and Robert Park theorized the city at the turn of the century, as the site where secondary relationships would strive, and where the "stranger" can find a new modern metropolitan sense of belonging.[12] The sidewalk thus was integrated into the imagination and design of urban housing. Suburban housing that privileged the automobile would eventually part ways with the sidewalk; no longer was life meant to be lived in the streets. Instead, the car produced

the social worlds, taken inside to the bigger house or the vehicular destinations (e.g., the mall, restaurants, social clubs).

As the racially segregated inner city/suburban landscape sedimented, urban sidewalks dotted with people of color imaged a culture of poverty and dystopia. In contrast, empty sidewalks, or better yet no sidewalk at all, signaled a racialized sense of social control, social propriety, privilege, and whiteness. As inner cities faced efforts of revitalization, the sidewalk was often a design focus of planners. Broken-window-themed community development efforts saw paving and beautifying sidewalks as a way to sanitize areas, particularly those marked by long histories of disinvestment. One way to rescue areas that were predominantly low-income and inhabited by people of color, the logic went, was to make sidewalks aesthetically pleasing. It is unclear what the effects of these aesthetic improvements are. Community Prevention Through Environment Design (CPTED) scholarship has found dubious impacts of built improvements on crime; for example, enhancing a psychological sense of safety, rather than actual safety, is thought to be the greatest benefit of CPTED interventions like gating.[13]

Gardens

Gardens and trees have long been symbols of prestige in the Western world and have been firmly tied to the concept of family and household.[14] The advent of the suburb as a respite from the city, best represented in Ebenezer Howard's concept of "town-country," highlighted the gardens and trees of rural landscapes as necessary to alleviate the ills and balance the benefits of urban life.[15] Gardens signal order and culture. A racial-scape then marked inner cities without gardens as destitute and uncultured. Mass public housing, with its institutional design and aesthetics devoid of personal touches, evoked the opposite of flowers: harshness, threat, disorder. The cared-for gardens image a scholarly representation of racial privilege and whiteness—an image that has considerable blind spots regarding the ways in which urban communities of

color have long participated in gardening cultures. In Bedford Stuyvesant in Brooklyn, block associations have long competed to be the "greenest" (aka most flower- and plant-curated) block in the borough. Communities of color also are responsible for an urban garden movement that mobilized for a botanically elaborated sense of ownership and connection to the land.

Flag and Christmas Lights

Donning the front yards of the home are elements that solidify the Americana landscape: a U.S. flag, Christmas lights, a porch swing. These elements can be viewed as symbols of the life inside and outside, of the markers of socially healthy community-making. But they also do some normative labor, framing the elements of proper living against an unstated "improper" home life. The flag and Christmas lights signal what William Walters calls "domopolitics," "a tactic which juxtaposes the 'warm words' of community, trust, and citizenship, with the danger words of a chaotic outside—illegals, traffickers, terrorists; a game which configures things as 'Us vs. Them.'"[16] The American flag is a symbol of nationalistic patriotism that simultaneously makes some feel safe and at home, while marking the "others." Christmas lights normalize the landscape as Christian. Together, they establish housing as a never neutral, politically infused geography that marks belonging or exclusion.

FIELD NOTES

In representations of houses, especially visible in real estate market listings, residential properties are often abstracted to what are seen as being neutral built environmental elements and

characteristics. Square footage, number of bedrooms and bathrooms, type of kitchen appliances, size of yard, and block and community are detailed carefully in listings to make homes ready for purchase. These seemingly neutral landscapes described in real estate listings, however, are realizations of the social histories that produced them. Through listings and the activated built environments that comprise and stage those listings, our social worlds and the physical inequalities that make way for them are reproduced.

These built environmental inequities manifest clearly in real estate pricing structures and systemic narrative practices that claim neutrality in the qualities of a property. By focusing on how the discrete elements that image a housing property activate histories of inequality, we can pinpoint mechanisms that deem certain experiences more valuable than others, as they have been made durable in built environments. How might we evaluate housing and neighborhood worthiness, value, and preferences if we considered the histories of their physical and social production? Might we valuate porches in ways that recognized their cultural functioning for Latino and Black families, while dissuading the use of flags in the marketing of a property? Might we challenge realtors to not deem gardenless communities as unsafe?

American inequality has been rather successfully disbursed by housing landscapes. Undoing inequality thus demands considering the physical built environment productions that make inequality real. While physically collapsing our housing geography is unviable, exposing the long-standing significations, symbolism, and corollary valuations (symbolic and monetary) that these built environments promote may effectively chip away at inequality's obduracy.

NOTES

1 Dianne S. Harris, *Little White Houses: How the Postwar Home Constructed Race in America* (Minneapolis: University of Minnesota Press, 2013).

2 N. Smith, P. Caris, and E. Wyly, "The 'Camden Syndrome' and the Menace of Suburban Decline: Residential Disinvestment and Its Discontents in Camden County, New Jersey," *Urban Affairs Review* 36, no. 4 (2001): 497–531.

3 Germaine Barnes, "[Housing] Destruction," *Journal of Architectural Education* 72, no. 1 (2018): 20–21; James Rojas, "Latino Urbanism: Transforming the Suburbs," *Buildipedia*, accessed July 15, 2013, http://buildipedia.com/aec-pros/urban-planning/latino -urbanism-transforming-the-suburbs.

4 Barnes, "[Housing] Destruction," 20–21; Audra D. S. Burch, "On the Front Porch, Black Life in Full View," *New York Times*, December 4, 2018.

5 Rojas, "Latino Urbanism."

6 Zaire Zenit Dinzey-Flores, *Locked In, Locked Out: Gated Communities of the Rich and Poor in a Puerto Rican City* (Philadelphia: University of Pennsylvania Press, 2013).

7 Mary Pattillo-McCoy, *Black Picket Fences: Privilege and Peril in the Black Middle Class Neighborhood* (Chicago: University of Chicago Press, 1999).

8 E. Franklin Frazier, *Black Bourgeoisie* (New York: Free Press, 1957); K. R. Lacy, *Blue-Chip Black: Race, Class, and Status in the New Black Middle Class* (Berkeley: University of California Press, 2007).

9 David Harvey, *Social Justice and the City* (Atlanta: University of Georgia Press, 2010).

10 Jane Jacobs, *Life and Death of Great American Cities* (New York: Vintage Books, 1961).

11 Annette M. Kim, "Critical Cartography 2.0: From 'Participatory Mapping' to Authored Visualizations of Power and People," *Landscape and Urban Planning* 142 (2015): 215–225.

12 W.E.B. Du Bois, *The Philadelphia Negro* (Philadelphia: University of Pennsylvania Press, 1899); Georg Simmel, "The Metropolis and Mental Life," in *The Urban Sociology Reader* (New York: Routledge, 2012), 37–45; Robert E. Park, "The City: Suggestions for

the Investigation of Human Behavior in the City Environment," *American Journal of Sociology* 20, no. 5 (1915): 577–612.

13 Edward J. Blakely and Mary G. Snyder, *Fortress America: Gated Communities in the United States* (New York: Brookings Institution Press, 1999).

14 John B. Jackson, *Landscapes: Selected Writings of JB Jackson* (Amherst: University of Massachusetts Press, 1970).

15 Ebenezer Howard, *Garden Cities of Tomorrow* (London: S. Sonnenschein, 1902).

16 William Walters, "Secure Borders, Safe Haven, Domopolitics," *Citizenship Studies* 8, no. 3 (2004): 237–260.

Fifth and State
Street, 1993

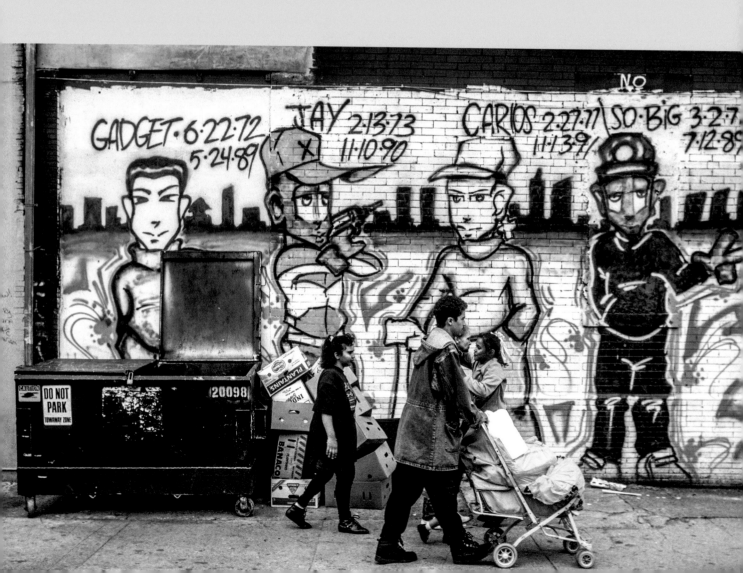

NO. 5 Symbols of Social Suffering

JACQUELINE OLVERA

Grief and death are part of the human experience. Most of us have suffered or will suffer the loss of a loved one caused by illness, accident, violence, natural disaster, or migration. And while popular discourse about grief tends toward personalized forms of bereavement, an image on a brick wall memorializing a slain friend, local hero, or cultural icon is a reminder that sorrow and loss are also collectively experienced. In urban neighborhoods, displays of collective grief are evinced by "Rest in Peace" messages scribbled on a billboard advertisement, engravings of a nickname on a school wall, and inscriptions of a person's date of birth and death on a public sidewalk. In many ways, a colorful and artistic image on a garage door or playground gives voice to shared pain and stress. Yet, there is disagreement among city officials and at times community members about how to express loss. In poor neighborhoods, an image spray-painted on private property, a public school, or public playground is characterized as a petty act of vandalism. The same image in the same neighborhood, if sponsored by a municipal program, might be considered street art; if commissioned by an organization, we might refer to the image as a memorial mural.

Whether framing public expressions of grief as art or disorder, it is useful to think about the image of a memorial to a deceased friend on a brick wall as a symbol of social suffering often visible in marginalized communities. Social suffering is the lived experience of pain, injury, and humiliation manifested in social spaces and caused by social, political, and economic exclusion.[1] A field guide to urban inequality about our urban past and present would thus be incomplete without attention to the broader social context in which people experience pain,

distress, and suffering. As such, this entry problematizes what counts as disorder or order and how interpretations of disorder are intimately linked to systems that police, exclude, and mark urban residents as they conduct their everyday lives.

FIELD MARKINGS

Vergara's photograph of a young family walking past a tribute to "Gadget," "Jay," "Carlos," and "So Big" reveals how tightly urban life and death are intertwined. Taken in 1993, on Fifth and State Street, the photo captures the short lives of four young men: "Gadget" and "Jay" had yet to reach their eighteenth birthday, "Carlos" was fourteen when he died, and "So Big" turned eighteen just four months prior to his death. Though we do not know how these young men died, the photograph shows that they transcended between 1989 and 1991, an important time in cities. This period marked a reduction in homicide rates in cities across the country. A good deal of credit for declining crime rates is attributed to policing tactics informed by "broken windows" theory. In 1982, James Q. Wilson and George Kelling argued that signs of physical disorder (such as smashed windows, garbage on streets, and graffiti on buildings) are a corollary to weak levels of social control in neighborhoods.[2] They further surmised that neighborhoods with low levels of social control invited criminals to act unchecked, presumably because indifference to happenings on urban streets dominated over intervention. Broken windows theory thus became the basis for policing petty lawbreaking in order to prevent more serious crimes. New York City is perhaps most famously known for using broken window policing tactics to crack down on behavior thought to signal physical and social disorder.

The effectiveness of this policing strategy has since been disputed. In 1999, Robert J. Sampson and Stephen W. Raudenbush conducted an exhaustive study of crime and its relationship to physical and social order in Chicago.[3] These social scientists carefully videotaped more than

23,000 streets in 196 neighborhoods. They recorded signs of physical disorder (e.g., abandoned cars, cigarette butts on streets, needles on sidewalks, empty beer bottles, graffiti, gang insignias) as well as social disorder (e.g., adult loitering, drinking alcohol in public, adults fighting, drug sales, prostitution). They took into account the time of day, the day of the week, and variability across blocks. In addition to systematizing the collection of disorder data, Sampson and Raudenbush examined details from police records, census information, and vital statistics. Analyses showed little support for broken windows theory. In fact, Sampson and Raudenbush found contradictory evidence—the relationship between physical disorder and crime is spurious (i.e., associated but not causal).

Despite the lack of (or moderate) empirical support for broken window theory, cities across the country designed and implemented policing strategies that linked disorder with crime. In the early 1990s, the cities of New York and Los Angeles charged their police to "clean up the streets" by cracking down on minor offenses such as tagging, graffiti, panhandling, smoking marijuana in public, jumping a subway turnstile, performing in public, or selling goods without a license. This brand of law and order eventually morphed into "stop and frisk" policing, whereby young men of color, most of whom likely share a number of characteristics with "Gadget," "Jay," "Carlos," and "So Big," were regularly detained, ticketed, and arrested in their own neighborhoods.[4]

Social suffering is endured collectively for reasons beyond policing strategies designed to control disorder and enforce compliance. Social misery is felt in the day-to-day experiences that accompany social exclusion as a consequence of poverty, segregation, and isolation. If we view the memorial wall in Vergara's photograph as a backdrop, we find a still moment in the everyday life of residents in Pyne Point, a neighborhood in Camden, New Jersey. Vergara puts into focus a young Latino family, walking along a cracked sidewalk, passing a dumpster and a set of neatly stacked cardboard boxes. The young man, perhaps following cultural norms, walking on the curbside, pushes a baby stroller filled with bags. A woman, mostly hidden from

view, carries a baby in her arms. This family strolls through Pyne Point in the 1990s, a New Jersey neighborhood where residents were 58 percent Latino, 38 percent Black, and about 3 percent White. Latinos in Pyne Point at that time were 50.6 percent Puerto Rican. In addition, 59 percent of families lived in poverty, 65 percent of residents had less than a high school education, and about 11 percent were unemployed.

These demographics suggest that in the 1990s, Pyne Point was a poor and mostly Black and Brown neighborhood. As a place, Pyne Point is like many urban neighborhoods changed by White flight and deindustrialization. It started as a White ethnic neighborhood, increasingly became African American, and then evolved into home for Puerto Ricans migrating from the island to Camden. Puerto Ricans were recruited to work in the Campbell Soup Company plant in Camden during World War II.[5] For some time, Campbell Soup was one of three big employers in the city, until it closed its plant doors in 1991. Over time, industrial jobs in Camden disappeared, as poverty and unemployment set in. These conditions surely set the stage for the uprisings that occurred near Pyne Point, after the beating of a Puerto Rican motorist by two police officers in the 1970s.

At the same time, Pyne Point was changing as a consequence of migratory diasporas from Latin America and the Caribbean. Indeed, the imagery of migrants making their way into White-ethnic, working-class neighborhoods, poor Black neighborhoods, and established Latino spaces shapes how we think about places like Pyne Point. At times, Latino neighborhoods are hailed as enclaves energized by ethnic enterprises that give meaning and form to economic life and opportunities. At other times, we salute these places for their dense network of organizations that connect residents to public services and support local civic life. But when these images do not align with what we see, we describe Latino neighborhoods as areas crippled by poverty and disorder, made worse by ongoing migration streams.

These depictions leave little room for envisioning contemporary Latino neighborhoods as products of geopolitical border crossings halted by urban spatial boundaries, urban politics,

and urban economics. It is easier to ignore suffering associated with traversing physical, social, and economic boundaries. And yet, the young family in Vergara's photograph challenges us to observe suffering and question representations of Latinos as "threats" to American society. Of course, doing so is no small feat. Leo Chavez, an anthropologist and immigration scholar, argues that national media play a large role in disseminating images of Latinos, in general, but Mexicans in particular, as "invaders" unwilling to incorporate into American life.[6] Chavez documents how newspapers and media pundits perpetuated stereotypes of Latino families as "breeders" of Brown babies who would grow up to be indifferent to American values. He describes the broad-brush assertions, circulated by media outlets, equating Latino population dynamics as the browning of America that would eventually lead to the rise of perpetual foreigners living in insular communities.

FIELD NOTES

It is very likely that the tribute to "Gadget," "Jay," "Carlos," and "So Big" in Vergara's photograph has since faded under the sun. However, the commemoration to these young men remains intact in this photo. Indeed, photographs of everyday urban life make it possible for us to share, express, and remember human joy and suffering. In cities, urban residents, often frustrated by inequality, use photography and street art to affirm the importance of neighborhoods and unearth deeply felt pain caused by social asymmetries. In many ways, this volume on American inequality does the same: readers bear witness to the pain caused by the death of these young men and the desire for public remembrance. Like the pictured image on the brick wall, this chapter exhorts readers to embrace the view that cities are places where collective pain and suffering are experienced.

Social injuries felt as a consequence of poverty and segregation are not unlike those Latinos are subjected to due to symbolic violence perpetuated by social institutions, such as the state

and media. These institutions have blamed, shamed, and exposed Latinos in cities. Consider the case of Puerto Ricans, stigmatized as "delinquent citizens" and ridiculed as "welfare dependent" for not making the most of their citizenship status.[7] Mexicans, in turn, are marked as "illegal" and as "drains" on social resources. Central Americans, too, find themselves stained. Public perceptions of Central Americans fleeing violence and seeking asylum encounter labels such as "criminal," "gang member," and "drug dealer," even if they arrive as children and infants. These labels serve as justification to deprive Latinos of resources and access to space and capital.

At other times, Latinos are rendered invisible by other social institutions. In the workplace, Latinos who clean our homes, cook our food, pick our fruit, and wash our cars often go unnoticed and unvalued. These workers suffer a myriad of indignities while performing low-wage work in the formal and informal economy. As long as Latinos remain socially invisible, it becomes difficult for workers to recognize their worth and thus more challenging for them to organize.

Interestingly, those of us who study cities too often overlook the collective pain experienced by Latinos who arrive as migrants in American cities to piece together opportunities. Most migrants, who leave home to begin a new life and escape poverty, violence, war, or lack of opportunity, do not arrive unscathed. For undocumented migrants, the journey to the United States is one of physical, emotional, and social pain.[8] If deported by the federal government, migrants are reinjured upon their return as they deal with the mark of "failed migrant."

NOTES

1 Pierre Bourdieu, *The Weight of the World: Social Suffering in Contemporary Society* (Stanford CA: Stanford University Press, 1999).

2 James Q. Wilson and George Kelling, "The Police and Neighborhood Safety: Broken Windows," *Atlantic*, March 1982, 29–38.

3 Robert J. Sampson and Stephen W. Raudenbush, "Systemic Social Observation of Public Spaces: A New Look at Disorder in Urban Neighborhoods," *American Journal of Sociology* 105, no. 3 (1999): 603–651.

4 Bernard Harcourt, *Illusion of Order: The False Promise of Broken Windows Policing* (Cambridge, MA: Harvard University Press, 2005).

5 Howard Gillette Jr., *Camden after the Fall: Decline and Renewal in a Post-industrial City* (Philadelphia: University of Pennsylvania Press, 2006).

6 Leo Chavez, *The Latino Threat: Constructing Immigrants, Citizens, and the Nation* (Stanford, CA: Stanford University Press, 2008).

7 Ana Ramos-Zayas, "Delinquent Citizenship, National Performances: Racialization, Surveillance, and the Politics of 'Worthiness' in Puerto Rican Chicago," in *Latinos and Citizenship: The Dilemma of Belonging*, ed. Suzanne Oboler (New York: Palgrave Macmillan, 2006), 275–300.

8 Jason De Leon, *The Land of Open Graves: Living and Dying on the Migrant Trail* (Berkeley: University of California Press, 2015).

Southwest corner
of Broadway and
Mt. Vernon, 1979

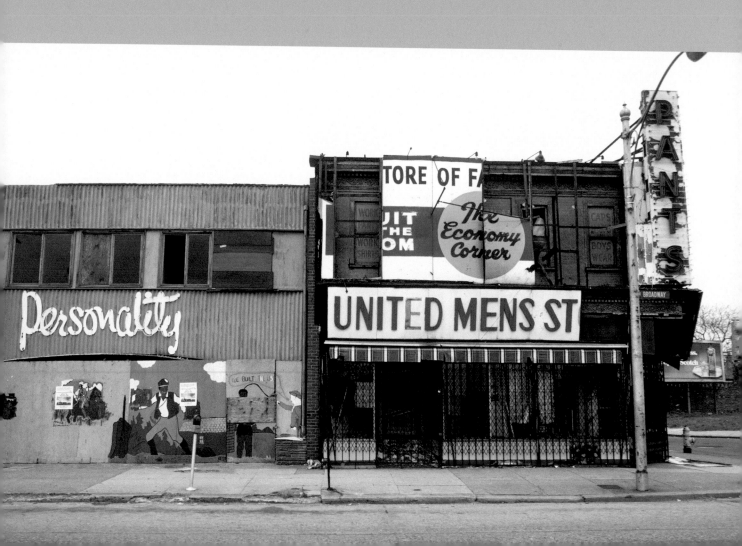

NO. 6 Dissonance

NAA OYO A. KWATE

It is logical to assume that in neighborhoods where inequalities are most palpably felt, streetscapes are unremitting catalogs of deprivation. That is, the buildings are in poor condition, and the goods and services on offer are cheap in price, quality, or both. However, perhaps a more visually distinct characteristic of urban inequality is dissonance. In communities where inequities pervade opportunity structures and day-to-day life, there are conflicting messages between building edifice and interiors; between craftsmanship of the edifice and the cost to inhabit it; between what is for sale and the purchasing power of the neighborhood; between supply and demand. In communities iconic for wealth, where the inequalities that undergird life there are not on display—say, the Upper East Side of New York City—neighborhood features converge around a single narrative of affluence. Things look expensive and they are. Museums there are thought to hold the world's most important collections of fine art. There are restaurants and expensive boutiques on clean boulevards, and architecture that is beautiful and took time to build. There is green space to play and explore. These community elements do not contradict the overarching narrative.

Elsewhere in the city, in gentrifying neighborhoods such as Brooklyn's Crown Heights, a cacophony of messages is etched in the landscape. As a case in point, a former corporate tax attorney and Toronto transplant opened a "boozy sandwich shop" she described as an "oasis" at the corner of Nostrand Avenue and St. Marks Place. The establishment's press release made note of the space, a former bodega "with a rumored backroom illegal gun shop to boot," and walls purported to be bullet-ridden—a visual feature that was to be preserved after renovation,

to be "cheeky"—but the claim was later debunked as false. Among the alcoholic beverages on offer was rosé served in glass bottles shaped like forty-ounce malt liquor containers, and labeled "FORTY OUNCE ROSÉ." Predictably, the marketing drew community protests, as residents decried the latent racism and mockery of structural conditions that made those "jokes" possible.[1] Liquor stores seem to hold particular cachet for gentrifiers who seek the gritty realism of urban social spaces. For example, DC's Shaw is home to an unmarked bar on Fourteenth Street NW with a "speakeasy" vibe. It serves its expensive cocktails adjacent to "a ghetto-style liquor store with plexiglass separating the customers from the merchandise, much of which is fifths of liquor."[2]

The opposing aesthetics between hipster speakeasy and securitized corner liquor store exemplifies the dissonance that characterizes urban communities in a context of inequality. Stable working-class and poor communities also evince varied cues of dissonance in the built environment. In Los Angeles, artist Mark Bradford reworks locally made advertising posters, layering on paint and other materials, and sanding down and manipulating the surfaces. The posters he incorporates in his work ask questions (and pose possible solutions) to an audience ranging from those merely curious about available services to the desperate. As one critic put it, the posters query, "Want something you can't afford? Need to do something that seems impossible? (or at least illegal?) There are many people willing to help you—particularly if you exist at either end of the economic spectrum." One billboard advertised the creation of a new credit file (LEGALLY!), "encouraging the question not only of veracity, but also about whom the laws actually serve."[3] The signage that festoons the fences, walls, and other structures in Black and Brown space with calls for homes to be bought, credit to be fixed, and other claims and schemes suggests a world apart from that in which residents live. These posters promise lifestyles premised on dubious claims, if not outright fantasy; they underline the divergence between the lives residents may wish to lead and those that they actually inhabit. In these ads inheres the dissonance that characterizes American inequality.

FIELD MARKINGS

The streetscape Vergara has captured on Broadway is rather a surrealist scene. In the distance, past the abandoned storefronts in the foreground, lies an empty lot, vacant save for an advertising panel. The staked 30-sheet outdoor media panel grows as an inorganic noxious weed, colonizing open space as ad panels do in Black neighborhoods.[4] Only a corner of the poster is visible, and the bottle design suggests that it is a promotion for Passport Scotch, a "light" whisky of the type that American importers began selling under bulk packaging practices. Beginning in the mid-1960s, alcoholic beverage makers forwent traditional bottles in order to save on import duties, and were thus able to sell bulk products for lower prices than already bottled drinks coming from abroad. Passport Scotch, Seagram's entry into that market under subsidiary Calvert Distillers, was one such repackaged Scotch. It arrived in 1968.[5] In May 1980, the brand was advertised in the *Baltimore Sun* with the following text: "At home or abroad, the satisfying taste of Passport Scotch turns any moment at all into a moment of enjoyment. World-famous Passport Scotch is made in Keith, Scotland from a blend of more than twenty of Scotland's finest malt and grain whiskies. Carefully controlled aging brings them to their peak in Passport, the world's first-class scotch. Enjoy the best. Ask for Passport Scotch. Because you enjoy going first class." It appears that an abbreviated version of the "first class" ad has appeared in the 30-sheet poster in Camden, made pithier to fit the constraints of the medium. Calvert Distillers advertised the brand in seemingly the same ways to all audiences, whether readers of the *New York Times* or *Ebony*, an unusual practice for most liquor brands. In any case, that the product is advertised at all is emblematic of the dissonance ingrained in urban inequality. Calvert's advertising agency pitched the spirit as comparable with "the most outrageously expensive whiskies that Scotland had to offer" and described its bulk bottling as saving the consumer's dollar on taxes, because "If no one else wants to look out for the rich, we will." The monied clientele to which that advertising beckons is far removed from the intersection of Broadway

and Mt. Vernon, Camden, but alcohol retailers apparently envision a market here. Or do they? The empty storefronts suggest otherwise.

That this street corner promotes discount Scotch is perhaps commensurate with the discount retail that once served patrons here. We are on The Economy Corner, however defunct. "UIT HE OM" was clearly once "Fruit of the Loom," one of the brands sold at the United Men's Store. It carried work pants, work shirts, caps, hats, boys wear, and PANTS: the durable apparel a working man needs. In 1955, the store was forward-looking, poised to serve a growing customer base. As described in a local newspaper account, "With the influx of new homes and population in South Jersey, the United Men's Store, 1019 Broadway, under the ownership of Jack Balaban, is embarking on a modernization program . . . in keeping with progress, the United Men's Store will be renovated both in the interior and exterior. The interior will feature the latest in modern lighting, insuring good visibility at all times, also the latest in attractive window displays."[6] Decades later, the store lies in ruin, a result of either the urban rebellion of 1971 that left stores on Broadway burned and vandalized, or the postindustrial flight of residents, businesses, and capital—or perhaps both.[7] The remains of the store fascia, in announcing the clothing that once was offered to Camden's working-class men, stand as a symbol of dissonance in the landscape. The broken signage now ironically declares this space as the "United Men's Street," but the street is far from embodying a kingdom of men. No longer can Camden's Black and Latino men have their retail needs met here. Indeed, they may not have the work that requires workwear, as residents in a city whose economy and labor market sustained drastic losses in the postindustrial age. Camden lost 48 percent of its manufacturing base between 1960 and 1970, trends that were equally present in cities such as Philadelphia (40 percent loss between 1967 and 1977), Chicago, Boston, and Pittsburgh (each lost more than 33 percent).[8]

Next door, another vacant building of unclear prior use contributes a variety of dissonant stimuli to passersby. The entire building appears to have been a temporary one, seemingly built of the corrugated tin roofing material that tops informal urban structures. The stand-alone word that graces the front—"Personality"—has an unclear referent. In the moment captured in this photograph, it

reads as if to say that the decrepit building has character, the kind that fans of "ruin porn" see in the decaying structures that make the rounds on the internet. The boards that cover the entryway have become a site for diverse expressions and discourse, with three different painted scenes. Two flyers have been posted, and although we cannot make out what they are announcing, the buildings displayed suggest something about the city of Camden specifically, or about urbanism generally. As with the posters Mark Bradford captures, the makeshift wooden walls have become a venue for disseminating specific messages, the printouts a means for notices to and about a local audience. The meaning behind the painted scenes may be lost to all but those involved in their creation or neighbors who resided in the area at the time. Farthest left, a lone man wearing what looks to be a Union army uniform rides a horse. In the center, a dark-skinned man from the American colonial era dominates the scene. He holds an active pose, perhaps ready to grab the rifle leaning against the tree trunk. He is enormous, towering over a house, stretching to the clouds—perhaps this is a man's street after all? Finally, on the right, a White man dressed in a blue uniform reminiscent of the Revolutionary War whips an apparent enslaved man. Moreover, he furthers this Black man's subjugation and denies his foundational contributions to the country's social and material world by declaring (or shouting, as the text is all in caps) "We Built the USA." This, perhaps, is the ultimate statement of dissonance in urban America: the idea that Whites are responsible for building the best that America has to offer, and those not classified as White were spectators alone. If this figure stands in for White America, it is meaningful that he confidently claims ownership for building the United States, but this is somehow meant to exclude the decay on which he rests—the very decay that in fact made his existence possible. Instead, the White imaginary sees Black people as having built a world of decay for themselves, rendering them nonparticipants in the city on a hill. A second plank of wood covers the Black man's torso, an additional layer of erasure that renders him partly invisible, at once questioning and articulating the country's view of blackness.

A final caveat, however, is that this entire scene takes place on Broadway; perhaps this is all a dramaturgical site that we ought not to take so seriously. It's as if Camden's urban fabric is actually the unimaginative result of a set designer whose stage was meant to allow whiteness to act out its

crises. Indeed, life is imitating art in just this way in the South Bronx. In 2015, developers who were in the midst of building a complex of market-rate apartments starting at $3,000 per month created a pop-up art show, "Macabre Suite," which welcomed visitors with trash can fires outside the door. They promoted the show with the slogan #thebronxisburning.[9] The tagline used as a marketing gimmick the devastation of the fires that ravaged the Bronx in the wake of the city's planned shrinkage policies, which deliberately reduced fire service in poor communities.[10]

FIELD NOTES

African Americans have long been shut out of commercial goods and services enjoyed by White counterparts or relegated to dysfunctional markets. It is important that liquor is the only visible retail good visible in this image of a former retail corridor. An abundant literature has shown that liquor stores and outdoor alcohol advertising occupy disproportionate space, messaging, and merchandise in Black neighborhoods.[11] In so doing, they have been a key means by which African Americans are encouraged to resolve dissonance. For those shut out of occupational success, accumulated wealth, and other touchstones of the American dream, liquor is offered as a useful stand-in. Champale, brewed in industrial Trenton, New Jersey, promised an effervescent, sophisticated social life with the slogan "Champale people know how to live." The January 1961 issue of *Ebony* contains an ad depicting an ornate glass goblet with sparkling bubbles and the tag "Makes the party!" Surrounding this are drawings of White couples and groups in evening wear, dancing and smiling in tony settings. Below them, other taglines: "Bubbly, bright, light Champale . . . puts Sparkle, Good Taste, Zing into your parties!" and "Look for Champale in the aristocratic green bottle." If alcohol could not alone catalyze social mobility and participation in affluent American consumption, *Ebony* readers had another alternative. Both preceding and following the Champale ad by a few pages were promotions for skin-bleaching creams. Nadinola Bleaching Cream declared that "LIFE IS MORE FUN when your complexion is clear, bright, Nadinola-light!" and

enjoined readers not to let "dull, dark skin" deprive them of popularity and romance. Posner's Skintona also would yield a "lighter, brighter, exciting skin tone!" and offered users a chance to "Be Modern." In this telling, the ultimate dissonance for African Americans was that blackness itself was retrograde; bleaching toward whiteness a literal path to modernity.

NOTES

1 Serena Dai, "Here's That Press Release Summerhill Sent about Its Bullet Hole Wall, in Full," accessed February 25, 2017, https://ny.eater.com.

2 Derek Hyra, "Selling a Black D.C. Neighborhood to White Millennials," accessed February 25, 2017, http://www.nextcity.org.

3 Heidi Zuckerman Jacobson, "Freedom without Love," in *Mark Bradford Merchant Posters* (New York: Gregory R. Miller, 2010), 11–17.

4 Naa Oyo A. Kwate and Tammy H. Lee, "Ghettoizing Outdoor Advertising: Disadvantage and Ad Panel Density in Black Neighborhoods," *Journal of Urban Health* 84 (2007): 21–31.

5 James J. Nagle, "Liquor Industry Trying New Labels," *New York Times*, October 13, 1968.

6 "United Men's Store Will Modernize," *Courier-Post*, March 7, 1955.

7 Howard Gillette Jr., *Camden after the Fall: Decline and Renewal in a Post-industrial City* (Philadelphia: University of Pennsylvania Press, 2006).

8 Gillette, *Camden after the Fall*.

9 Winnie Hu, "Bronx Pop-Up Art Show Prompts Criticism That It Invoked Borough's Painful Past," *New York Times*, November 6, 2015.

10 Deborah Wallace and Rodrick Wallace, *A Plague on Your Houses: How New York Was Burned Down and National Public Health Crumbled* (New York: Verso, 1998).

11 Ethan M. Berke, Susanne E. Tanski, Eugene Demidenko, Jennifer Alford-Teaster, Xun Shi, and James D. Sargeant, "Alcohol Retail Density and Demographic Predictors of Health Disparities: A Geographic Analysis," *American Journal of Public Health* 100, no. 10 (2010): 1967–1971.

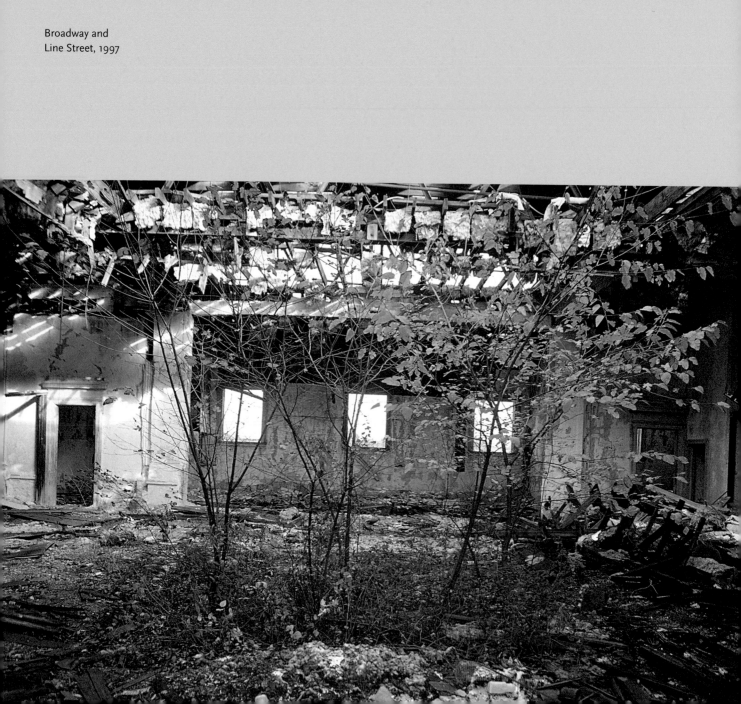

Broadway and
Line Street, 1997

NO. 7 Race, Gentrification, and the Making of Domestic Refugees

STACEY SUTTON

Increasingly, the media recounts how gentrification maps onto racial inequalities. For instance, the title of an incendiary article in the *New York Times* proclaims, "The End of Black Harlem."[1] This critical and deeply personal exposé of the signs and meanings of gentrification also expounds communal fear that Harlem, a worldwide symbol of Black culture, is being erased. Even affluent Black Harlemites who are generally enthusiastic about the accoutrements of gentrification—pristinely renovated nineteenth-century townhomes, new luxury high-rises, manicured parks and beautified plazas and public spaces, Whole Foods, patisseries and chic restaurants—lament that "our Harlem is being remade, upgraded and transformed, just for them, for wealthier white people." Ironically, by 2016, the neighborhood that long-standing Black Harlemites helped to stabilize and that welcomed Black newcomers home was becoming increasingly exclusionary and unsafe for Black people who are repeatedly surveilled and stereotyped as threatening outsiders.

Similar paradoxical accounts have been documented for numerous gentrifying American cities, as in a newspaper article titled "A Striking Evolution in Bedford-Stuyvesant as the White Population Soars."[2] Another journalist highlights the irony of gentrification in an article titled "The Neighborhood Is Mostly Black, the Home Buyers Are Mostly White."[3] Still another has titled an article "Gentrification in Detroit Leaves Black-Owned Business Behind."[4] And as the Black population in Washington, DC, slipped below 50 percent for first time in

more than fifty years, gentrification is often blamed. Racialized conflicts and spatial insecurities are in full view amid gentrification. The common refrain across many gentrifying cities is that long-standing Black residents are cynical or ambivalent about contemporary processes of neighborhood improvement because it is posited that they often see the development as an ominous harbinger of displacement and erasure of Black culture.

There has been increasing popular and political attention to racial dimensions of gentrification in addition to its economic underpinnings. Though it is widely assumed that gentrification manifests through an influx of White affluent residents, concomitantly displacing Black and Latinx incumbents, in actuality the process is far more complicated. Most important, it is a spatial expression of power asymmetries and inequalities that are often racialized. Until recently, empirical studies painted a racially muted picture. When British sociologist Ruth Glass first introduced the term "gentrification" into the lexicon of urban scholarship in 1964, it characterized spatialized *class* conflict with no explicit attention to race. During the earliest waves of gentrification, working-class (White) residents were displaced by upper-income (White) newcomers. Affluent consumers acquired modest cottages, beleaguered townhomes, and tattered industrial spaces in working-class neighborhoods and converted them into posh residences. While gentrification during the 1960s and 1970s in New York City's SoHo, Baltimore's Federal Hill, and Philadelphia's Society Hill was vilified by neighborhood advocates for displacing working-class residents, it was simultaneously lauded by local government and city boosters for curtailing White flight and stabilizing declining cities.[5]

Fifty years later, gentrification remains principally a spatial expression of wealth inequality that sits atop existing racial geographies of injustice and produces new racial patterns across urban landscapes. As processes of gentrification have advanced, both temporally and geographically, neighborhoods that were previously labeled Black "ghettos," stigmatized as unsafe places to avoid or escape, and deemed impervious to renewal are becoming the newest hotbeds

of gentrification. They are new frontiers for a confluence of land-use decisions, neoliberal policies, urban governance structures, and private equity investments that prioritize development over social equity.

Why now? Gentrification exploits preexisting cleavages in search of a "rent gap" or profitable possibilities for consuming real estate.[6] Consequently, America's racial legacy of blockbusting, redlining, White flight, segregation, and disinvestment is a doorway through which contemporary processes of gentrification enter, traverse inner-city Black neighborhoods, and intersect with America's durable racial hierarchy. Though gentrification was not conceived as a racial project, it is becoming a racial project because the power asymmetries between consumer and consumed are increasingly racialized since the most desirable working-class White neighborhoods are already gentrified and monied consumers are disproportionately White.

Processes of gentrification are transforming Black ghettos. Places in the popular imagination understood one-dimensionally as poor, bleak, and barren urban landscapes typified by social disorganization and a dearth of collective efficacy have become hot spots. The transition is abetted by local government accepting the ghetto trope, thus ignoring preservationist policies and community benefit agreements or dismissing them as a hindrance to development and city building.

A good example is the debacle between President Barak Obama and advocates and residents of Woodlawn, a poor Black community on Chicago's South Side. Obama rebuffed community concerns that locating the Obama Presidential Center and Library would foment gentrification. When the community asked for concessions and assurances, Obama retorted that "we have such a long way to go before you will start seeing the prospect of gentrification." This response adopts a calcified frame of Woodlawn as ghetto and projects the tacit message that the community should embrace development as a public good, despite it not being equitable. It

also blatantly ignores endogenous revitalization catalyzed by community organizations, civic leaders, and residents and the reality that gentrification is already encroaching.

FIELD MARKINGS

The skeleton structure in Vergara's image was once a public library, a public institution for democratizing knowledge, community building, and creating sanctuary. But the ruins—disintegrating steel beams, crumbling cement, splintered timber trusses absent the accompanying roof, and nature pushing through the floorboards—are a testament to decades of local government neglect, disregard, and failure to protect public interests. It is not possible to discern whether the primary assault to the architecture was a cataclysmic event or whether incessant disregard, shortsighted planning, and ill-advised land-use policies disintegrated an otherwise solid structure. Both possibilities are familiar tactics amid fiscal austerity, entrepreneurial governance, winner-take-all urban development, and reliance on gentrification as a solution to seemingly intractable urban problems.

This image raises questions about what it means for local governments to shirk their responsibility for maintaining the integrity of public goods, like parks, plazas, libraries, and school buildings, and protecting the welfare of residents by allowing public property to become blighted. The term "blight" is borrowed from botany, where it refers to plant disease marked by the formation of lesions, browning, and likely death of plant tissue caused by exogenous pathogenic organisms. When applied to urban properties, it marks decrepitude and disrepair and motivates government actors to condemn as a strategy for eschewing contagion. The concept of blight is part of the legal framework of property law. Labeling properties blighted, much like classifying neighborhoods as ghettos, is deceptively caustic. In working-class neighborhoods it

is a rhetorical device that enables city planners and real estate developers to seize private property for private projects. It is commonly invoked as a pretext for large-scale redevelopment projects that result in gentrification, displacement, and dispossession.

The image divulges the neighborhood's above-average rates of poverty, poor schools, crumbling infrastructure, dearth of amenities, and overwhelming Black (or Latinx) population. In poor neighborhoods, blight is protracted. It justifies property abandonment and sustained institutional disinvestment, and it eschews policy protections to thwart gentrification. When local governments allow public properties to remain blighted, they are complicit in perpetuating ghettoization based on the assumption that, eventually, residents will exalt unbridled development irrespective of deleterious effects.

What we do not see in this image, yet it underpins the cycle of ghettoization and gentrification, is the rise of entrepreneurial urban governance. As local governments are increasingly thrust into an intra- and interurban competitive marketplace, they hedge their bets on neighborhoods. In areas considered promising or stable, municipal leaders leverage the full weight of valuable public resources—land, buildings, infrastructure, utilities, taxes, and financing—to generate more stability in the form of goodwill, jobs, fiscal health, safety, and livability. Ironically, in areas of need, it is not uncommon for municipal leaders to compound menacing conditions with extractive economic development schemes.

FIELD NOTES

While city boosters and investors may glibly cheer good riddance to urban decline and extol gentrification for solving myriad urban problems, there is no assuaging the new urban crisis that gentrification animates. The *original urban crisis* was created by deindustrialization, housing

discrimination, segregation, suburbanization, and devalorization of Black space that constructed Black ghettos. The *new urban crisis* is typified by displacement, social and cultural exclusion, and dispossession caused by gentrification. The dialectical relationship between these crises, ghettoization and gentrification, can be understood through the specter of safety.

The media, policy makers, planners, and academics construct and reinforce imagery that is ensconced in the popular imagination. Black spaces are characterized by crime, violence, nefarious business, and licentious activity, and Black sociality as an insurgent nuisance to be fixed and controlled. These frames strip agency from Black residents who choose to locate in Black spaces because they are presumed to be relegated to these spaces. Conventional one-dimensional frames center the outsider looking in. As such, they ignore community complexity and how Black spaces are sites for Black economic creation, cultural production, institution building, political organizing, and social attachments. From this outsider frame, gentrification is more likely embraced as a necessary strategy for smoothing the rough edges of inner-city neighborhoods. But as neighborhoods change to accommodate more affluent White residents, they become less safe and less accommodating for Black residents. Surely, class difference moderates disparate treatment of blackness in gentrifying neighborhoods—by the police and local state, new neighbors and business owners, real estate brokers and civic associations—but it does not eliminate it. Black residents across class experience degrees of harassment while doing daily activities, surveillance in public spaces, stereotyping of mobile Black sociality walking down the street, and housing discrimination.

From Portland to Austin and Boston to Atlanta, historic Black neighborhoods that cultivated Black freedom fighters, birthed Black enterprise, protected Black art, and validated the Black aesthetic are gentrifying at alarming rates. Neighborhoods previously marked by White avoidance and capital flight are now hot spots for million-dollar mansions, luxury lofts, celebrity chef restaurants, artisanal breweries, and wine bars. They are unaffordable and largely

unrecognizable to long-standing residents and small business owners; they are also becoming unsafe for Black residents.

Gentrification is not new, but the twenty-first-century variant is creating a new urban crisis manifesting in an unprecedented exodus of Black residents from major cities, shuttering of Black-owned businesses, and growing unemployment, housing insecurity, and dispossession. This new urban crisis is creating "domestic refugees," unwelcomed in cities and neighborhoods that were once home. This crisis has been imminent for some time but was always obscured by more pressing social concerns. During the 1980s and 1990s, social scientists and policy makers explored impressionistic claims of gentrification and Black resident removal in Central Harlem. But signs of upgrading were obfuscated by blocks of blight. At the time, Central Harlem was approximately 96 percent Black, and researchers found no evidence of racial transition. Instead, they attributed nascent gentrification to a few affluent Black households relocating to Harlem.[7] Yet researchers deduced that if processes of gentrification proceeded, it would eventually lead to an influx of Whites and Black displacement. It was evident, even then, that the racial wealth gap limits Black affluence, thus curtailing Black households' ability to afford Central Harlem as market pressures advanced. Fast-forward to 2017, to when unfettered development and regressive policies have transformed Central Harlem into a chic and largely unaffordable district that was 53 percent Black and declining, along with the significance of Harlem as a locus of Black culture, economy, and polity.

The new racial patterns of gentrification foreground the new urban crisis in five ways: First, the lens of racial inequality illuminates the myriad ways, both legal and predatory, that gentrification is pushing the Black middle class out of historically Black enclaves.[8] Second, residents able to remain in gentrifying neighborhoods express feeling socially excluded, isolated, surveilled, and tormented by the loss of their community. Third, ghetto residents seemingly outside of the direct path of gentrification's progression live with anxiety of imminent displacement

and further housing precarity. Fourth, this is a crisis because local governments are failing to treat it as such; most cities have nonexistent or insufficient policies to curtail gentrification's progression. Finally, gentrification-related racial integration is frequently lauded as an antidote to entrenched segregation. However, a report for the Joint Center for Housing Studies of Harvard University concludes that "gentrification offers the promise of inclusivity. But left to its own devices, the market is unlikely to deliver on that promise."[9] In other words, absent policy intervention, the crisis will continue.

NOTES

1 Michael Henry Adams, "The End of Black Harlem," *New York Times*, May 29, 2016, https://www.nytimes.com/2016/05/29/opinion/sunday/the-end-of-black-harlem.html.

2 S. Roberts, "A Striking Evolution in Bedford-Stuyvesant as the White Population Soars," *New York Times*, August 5, 2011, A19.

3 Emily Badger, Quoctrung Bui, and Robert Gebeloff, "The Neighborhood Is Mostly Black, the Home Buyers Are Mostly White," *New York Times*, April 27, 2019, https://www.nytimes.com/interactive/2019/04/27/upshot/diversity-housing-maps-raleigh-gentrification.html.

4 K. H. Taylor, "Gentrification of Detroit Leaves Black-Owned Business Behind," NBC News, November 1, 2015, http://www.nbcnews.com/news/nbcblk/gentrification-detroit-leaves-black-residents-behind-n412476.

5 Neil Smith, "Toward a Theory of Gentrification: A Back to the City Movement by Capital, Not People," *Journal of the American Planning Association* 45, no. 4 (1979): 538–548.

6 Neil Smith, *The New Urban Frontier: Gentrification and the Revanchist City* (New York: Routledge, 1996). The rent gap, a central concept to gentrification, is the difference between the current rental value of a depressed property and the potential rent achievable.

7 R. Schaffer and N. Smith, "The Gentrification of Harlem?," *Annals of the Association of American Geographers* 76, no. 3 (1986): 347–365.

8 See Keeanga-Yamahtta Taylor, *Race for Profit: How Banks and the Real Estate Industry Undermined Black Homeownership* (Chapel Hill: University of North Carolina Press, 2019).

9 Ingrid Gould Ellen, *Can Gentrification Be Inclusive?*, Joint Center for Housing Studies of Harvard University, May 16, 2018.

SOCIAL STORIES AND STIGMATIZED SPACE

NO. 8 Housing Segregation and the Forgotten Latino American Story

JACOB S. RUGH

What is America to me?" White American Frank Sinatra and Black American Paul Robeson famously sang distinct replies to this question in their respective versions of the 1940s tune "The House I Live In." Sinatra briefly mentioned "all races and religions" near the end of his third verse. Robeson's reply led his second verse and was more specific, "My neighbors, white and black, the people who just came here, or from generations back." Robeson's more racially inclusive lyrics raise further questions: Who are the people "who just came"? Many White Americans may reflexively react to Vergara's photographs of urban American housing and insist, "That is not America to me." White onlookers may assume it is not America because of stereotypes of Black America. The truth defies the extremes of the Black/White binary because most residents of such urban neighborhoods are neither White nor Black but Latino. The most racially segregated and disadvantaged Latinos in urban America are Puerto Ricans and Dominicans. Puerto Rican settlement on the U.S. mainland reached its apex "generations back," just after Robeson's time, during the 1950s postwar housing construction boom; Dominicans are often new immigrants and, increasingly, domestic migrants, who "just came" to some of the nation's most historically disadvantaged neighborhoods. In short, to understand the problems—and the solutions—in today's urban neighborhoods, we cannot afford to erase Latinos from the narrative.

The stories we tell have power. The stories and images of our past exert social control because those who have died can no longer contest them. Recent history, however, is contested because

its participants are still alive. The contested history of urban America is strained further by racialized divisions deeply entrenched in racially segregated housing. From racial covenants, bombings, mortgage redlining, and segregated public housing and corresponding schools to targeted policing, subprime lending, and re-redlining, housing remains the site where our nation's racial divide persists and continues to evolve. Yet, mainstream society lacks a shared consensus of what exactly happened to our most disadvantaged cities and their residents.

Scholars have documented how racialized public policy enabled mass-produced suburban housing and a mass investment in whiteness; the very same policies rendered urban America blackness made concrete. These distant forces echo powerfully into the present. Housing is the greatest source of household wealth, and people of color are more likely to hold what little wealth they have in the form of home equity. For every dollar of wealth owned by the typical White family, Black families own ten cents, and Latino families, just thirteen cents. Black and Latino homeowners in communities of color not only have less wealth for down payments but also see their properties appreciate at lower rates, and they are left with less to pass on to the next generation. However, a financial accounting of the geographic inscription of Black spaces that are increasingly Latino is far too narrow: the next generation does not inherit just wealth or debt; it also inherits neighborhoods and all the concomitant earned advantage or disadvantage, including schools, exposure to toxic pollutants like lead and particulate matter that cause asthma, violence, and social networks that either undermine or open opportunities in higher education and the workplace.

FIELD MARKINGS

Like housing itself, images of urban housing reflect racial inequality. Images may also reinforce it. Absent proper contextualization, urban iconography may fuel racialized narratives as

a result, whether pictures of Detroit in ruin or of citizen self-determination in the face of police brutality in Baltimore and scores of other cities.

On Pearl Street, in 1979, we find five clues to a forgotten story of Latino residential stratification in urban America. First, in the background beyond Pearl Street, we see two towers, one completed and half obscured, and the other more plainly in view yet half constructed. Again, at first glance, the construction resembles the common stereotype of housing projects in disrepair, but the pattern of rising glass and the scaffolding at the right are two clues that this tower is not in disrepair but in progress. Northgate II, this half-constructed apartment high-rise, would be completed in 1979. The Northgate II apartments and surrounding block are home to more residents than ever today, a vital source of affordable housing for residents over age fifty-five.

In the foreground lies a second clue, among the homes on the north (right) side of the Pearl Street block. Most still exist today, but census records at the block level show that the population of this surrounding block has plummeted from 148 residents in 1970 to 47 today. Unlike the towers, where the aging of America has replenished their units, only 9 percent of residents of the Pearl Street block are over fifty-five years old. Many of the homes are vacant and boarded up, yet three are painted bright colors reminiscent of the Caribbean and Latin America. The burned-out commercial establishment on the corner at the right became a Pentecostal church in the 1990s; it still stands today as a harbinger of the diversification of Evangelicals and defies White Evangelical stereotypes.

In the background, we see in the distance a dim but unmistakable image of the Ben Franklin Bridge. Benjamin Franklin, "a cautious abolitionist," is commemorated in many ways today, including at the Pennsylvania Abolition Society markers in Philadelphia, which lie across the bridge. The bridge connects to the interstate freeway system that vivisected urban communities of color but serves as a way for White suburbanites to safely visit the Liberty Bell and Independence Hall and to quickly drive by racially isolated neighborhoods in Philadelphia and Camden.

Mortgage redlining by federal housing agencies and banks deliberately excluded attached structures like the row homes, and finance exploitation often replaced such systems of exclusion. The row homes of Richmond, Washington, Baltimore, Philadelphia, and smaller yet relatively more devastated cities like Camden, Chester, and Trenton are a visual reminder of the devastating effect of past lending practices governed by federal policies. Specifically, the Federal Housing Administration did not guarantee mortgages on attached homes like the housing characteristic of so many cities in the northeastern and mid-Atlantic states. Officially, this policy was race-neutral, but in effect it produced tremendous disparities by race.

Two young Latino boys occupy a central place in this snapshot from 1979, one running forward, and one stopped to consider the photographer. This intriguing image reminds us that people live, play, and work in Camden and across urban America. The symbolism here is powerful. While a portion of those who are raised in such neighborhoods will continue to be on the move, residing elsewhere forty years later, others will consider the gaze of the outsider to either claim a Black identity, a White identity, or a unique Latino identity. Research has demonstrated that Latinos often either resist or internalize the ideology and practices of the dominant mainstream society. These may include voting for candidates who deport their fellow co-ethnics, other Latinos, even their spouses or, alternatively, finding solidarity with Black Americans in the struggle for civil rights and immigrant rights. Interestingly, research by Julie Dowling, Nicholas Vargas, Robert Smith, Nilda Flores-Gonzales, and others has shown that the racial ideology of Latinos has less to do with skin tone, assimilation, or generation but is powerfully anchored in how they see themselves as Americans and who they see as their reference group—White Americans, or Black Americans and other people of color.[1] Some Latinos measure their opportunity and success using a White standard for citizenship, which may be reflected in their choice to inhabit White spaces and emulate White practices. For other Latinos, particularly Puerto Ricans and Dominicans, their journey of becoming fully American

means that they become Latino American, firmly entrenched in a non-White identity more like their Black neighbors.

FIELD NOTES

In Camden and other economically distressed cities across the United States, the mayor and city council leadership are all Black and Latino. The official history of Camden on the city's website—more than 4,600 words long—reviews multiple centuries and mentions several European ethnic groups and some native peoples. In a stunning omission, this long history makes no mention whatsoever of long-standing Puerto Rican and African American settlement or more recent immigration from Latin America and elsewhere. The history of the past three generations is simply missing, frozen in the segregated 1940s world of Sinatra and Robeson. The visitor to Camden is left either to wonder or, more likely, to assume what happened in urban America. The pronouncement of the 1968 Kerner Commission report—that our society was fracturing into two, "one white, and one black"—does not fully capture what happened on streets across America like Pearl and Ninth in Camden from the time Vergara documented them in 1979. Rather, images and evidence reveal a hidden, forgotten Latino American story.

In 1970, less than 5 percent of the U.S. population was classified by the Census Bureau as Hispanic, a new category used for the first time in 1970 that grouped together Mexican, Puerto Ricans, Cubans, and Latin American origin groups. This category was a politically negotiated "ethnicity" category that has become racialized over time.[2] Today, about 18 percent of the U.S. population is Hispanic or Latino. Nearly 40 percent of Latinos are not of Mexican descent. These categories matter because many Latinos of Caribbean descent are inheriting Black spaces that have never been fully African American but have a history of Puerto Rican settlement and

are becoming increasingly Dominican. As in many neighborhoods in the Northeast, most Latinos in Camden are Puerto Rican or Dominican. The Dominican population has increased rapidly in North Camden and in smaller cities like Reading, Pennsylvania; and Providence, Rhode Island.

Puerto Ricans have long occupied a residential, social, and racial position in American society closer to Black than White, and closer to Black than other Latinos. This fate is no accident. Rather, it is a product of structural racism located in historical context. A combination of colonization and subjugation on the island of Puerto Rico and peak migration and settlement in racially segregated cities of the U.S. mainland in the pre–civil rights era (Chicago, New York, Philadelphia) locked generations of Puerto Ricans into neighborhood disinvestment and disadvantage. As scholars and advocates of the Puerto Rican community have long argued, their plight, struggle, and victories are overshadowed by the U.S. Black/White dichotomy that erases other people of color, especially Latinos who self-identify as racially mixed or by nationality and reject such a false binary.[3]

The residential and racial fate of Dominicans is a product of structural forces that overlap with Puerto Ricans—yet that differ in important ways. While Puerto Ricans have been U.S. citizens for more than a hundred years, most Dominicans are immigrants; many are not yet naturalized citizens, and others remain undocumented. Noncitizen Dominican immigrants face a triple set of risks. First, because Dominicans live in residentially isolated neighborhoods near Black Americans like North Camden and Washington Heights, New York, they are subject to greater police surveillance and racial profiling. Dominicans are more likely to self-identify as Black, and even more likely to be viewed as Black by others.

Second, these practices of racialized social control jeopardize Dominicans on the basis of race and legality due to the rise of police practices that check the immigration status of those profiled as foreign born due to skin tone, spoken accent, or simple neighborhood perception as a Black space. Those who fell out of legal status at very young ages and legal permanent

residents may also be deported for past infractions, however minimal, decades later. Local law enforcement agreements with U.S. Immigration and Customs Enforcement, like 287(g) task forces, have resulted in the deportation of millions of Latin American immigrants. Mexicans, Central Americans, and Dominicans, who make up less than 70 percent of the undocumented population, constitute more than 95 percent of the deported.[4] For undocumented Latinos and arguably all Latinos, race is truly being made in real time, especially for undocumented Dominicans who are socially, residentially, or visibly constructed as Black. When deported Dominicans return to the island of the Dominican Republic, most confront institutionalized social stigma; they are labeled criminals, and job opportunities in the formal sector are severely curtailed. Those deemed as racially suspicious by anti-Black policies have stripped thousands of Dominicans of Haitian descent of their citizenship, dignity, and right to live in the Dominican Republic.[5]

The phrases "inner cities," "urban decline," and "a culture of poverty" not only conjure euphemisms but also perpetuate racism. If euphemisms conceal meaning, racist euphemisms erase people, agency, and truth. In the case of housing, neat and tidy narratives about the civil rights movement ending in the 1960s erase the truth that millions of Latino Americans continue to be racially segregated and discriminated against along with their Black American neighbors. The truth is that Latino-White segregation has not faded at all in the post–civil rights era. In many places, like Camden, New Jersey; Reading, Pennsylvania; and Springfield, Massachusetts, Latinos are extremely racially isolated and face multigenerational disadvantage in terms of housing, schools, crime, employment, and environmental racism. The euphemisms cloak agency because Latino Americans have joined Black Americans in common cause to advance racial equality.[6] Unfinished multiracial Black and Latino antiracist struggles (and Asian and Native alliances) are erased by platitudes that flatten and separate the civil rights movement into distinct endeavors by race and region, and long ago completed. Across urban America, Black and Latino citizens call out the empty promises of equality without investments

in disinvested communities as a "bad check, marked insufficient funds," as Dr. King famously and righteously asserted.[7]

An imagined racially superior past suppresses and erases people of color—from the massacre of Black Americans in Tulsa, Oklahoma, to the struggle for Latino American self-determination in New York, Sacramento, and even San Juan. North Camden, the South Bronx, South Los Angeles, North Las Vegas, South Mountain Phoenix, South Dallas, Houston's Greater Fifth Ward: across these historically "Black" sides of town, the majority population today is Latino. In the case of long-standing, multigenerational Puerto Rican settlement in Camden, Latinos have always been integral to Black communities, but hidden by America's distorted racial lens.

Vergara took this iconic photo layered in history and meaning in 1979. The 1970s and 1980s are in between the history of Puerto Rican settlement and present Dominican dispersal. The Latino story is also neither past nor present, neither Black nor White, but instead, diverse, bordered, unfinished, and contested by Latinos and non-Latinos alike.[8] However, the forgotten Latino story of Puerto Ricans and Dominicans in particular is tied to the Black American story of liberation and the right to housing, and will surely shape the question of the American future: Will the United States grant Black and Latino citizens the opportunity to achieve the American dream? Will society block their chance to redefine racial and residential boundaries, and to answer for themselves, "What is America to me?"

NOTES

1 Nilda Flores-González, *Citizens but Not Americans: Race and Belonging among Latino Millennials* (New York: New York University Press, 2017); Robert C. Smith, "Black Mexicans, Conjunctural Ethnicity, and Operating Identities: Long-term Ethnographic Analysis," *American Sociological Review* 79 (2014): 517–548; Jody Agius Vallejo, *Barrios to Burbs: The Making of the Mexican American Middle Class* (Stanford, CA: Stanford University Press, 2012); Nicholas Vargas, "Latina/o Whitening?: Which Latina/os

Self-Classify as White and Report Being Perceived as White by Other Americans?," *Du Bois Review: Social Science Research on Race* 12 (2015): 119–136.

2 Cristina Mora, *Making Hispanics: How Activists, Bureaucrats, and Media Constructed a New American* (Chicago: University of Chicago Press, 2014).

3 Wendy Roth, *Race Migrations: Latinos and the Cultural Transformation of Race* (Stanford, CA: Stanford University Press, 2012).

4 Jacob S. Rugh and Matthew Hall, "Deporting the American Dream: Immigration Enforcement and Latino Foreclosures," *Sociological Science* 3 (2016): 1053–1076, https://www.doi.org/10.15195/v3.a46.

5 Tanya Maria Golash-Boza, *Deported: Immigrant Policing, Disposable Labor and Global Capitalism* (New York: New York University Press, 2015).

6 Alyssa Ribeiro, "Forgotten Residents Fighting Back: The Ludlow Community Association and Neighborhood Improvement in Philadelphia," in *Civil Rights and Beyond: African American and Latino/a Activism in the Twentieth-Century United States*, ed. Brian D. Behnken (Athens: University of Georgia Press, 2016), 172–194.

7 Martin Luther King, "I Have a Dream" (speech delivered at the March on Washington for Jobs and Freedom, Washington, DC, August 1968), http://avalon.law.yale.edu/20th_century/mlk01.asp.

8 Ed Morales, *Latinx: The New Force in American Politics and Culture* (Brooklyn, NY: Verso Books, 2018).

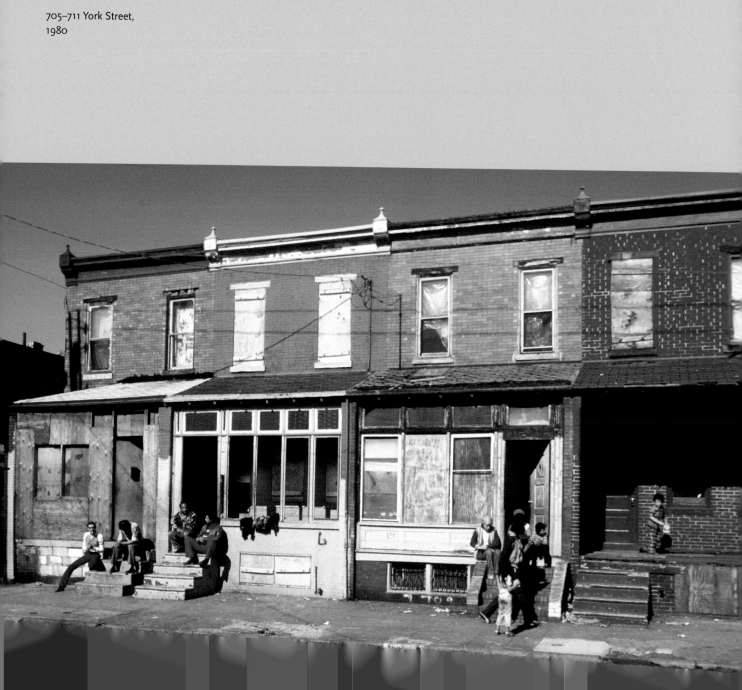

705–711 York Street,
1980

NO. 9 Stolen Narratives
and Racialized Structural Inequality

JAY A. PEARSON

Inequality in the United States is deeply racialized. Whites claimed a disproportionate share of the emerging nation's resources, power, status, and influence. Driven by historical impetus, these unfair advantages operate in contemporary times to maintain and perpetuate a rigid race-based social hierarchy. American social hierarchies are rooted in European immigrants having constructed and enforced racial categories in order to justify material and economic exploitation of Native American and West African populations, respectively. European Americans considered themselves naturally superior, worthy, and deserving of human dignity and appointed "White" as the dominant racial group while assigning what they considered inherently inferior "Red" and "Black" populations to dehumanizing subaltern social positions. Beliefs, values, and norms reflecting these and related notions of White racial supremacy then informed the country's institutions through racialized legislative processes. Essentially, White racial belief in nonexistent racial difference led to racially biased policies that made race a social reality. Consequently, U.S. race-based social inequality is a function of how the nation was constructed from the perspective and to the benefit of White Americans. Operating across multiple dimensions as well as at multiple levels of influence within society, racialized structural inequality has dire consequences for Black and Brown lives.

Because Whites in the United States are able to self-determine their ethnoracial identity and then impose racial identities on "inferior" others, they can set upper- and lower-bound

social constraints that define life chances along racial lines. Yet, efforts by populations of color to self-determine with strategies of resistance, whether adaptive behavioral responses, alternative economic enterprises, or otherwise, have been met with combinations of condemnation and disruptive public policy decision-making.

Who has gotten to tell the nation's race story, how they have chosen to tell it, and the extent to which that story is reinforced with structural and institutional mechanisms reveal much about American inequality. The American race story is evident in at least three ways.

A Meritocratic Republic

Notions of an egalitarian, meritocratic United States were established early in the nation's history and are inextricably linked to national identity. Work hard, sacrifice, and you can achieve the American dream. Simultaneously, over the course of our history, notions of race were established early—also closely linked to national identity and serving as a fundamental unit of social organization and division. Profound racial biases pervade virtually every dimension of human interaction, in direct contradiction to narratives of a just and fair nation. Who worked harder for the nascent nation than enslaved Black Africans, and who sacrificed more for it than red Native Americans? Interpretive contentions between these parallel but opposing narratives about American meritocracy are at the crux of racialized structural inequality.

Where there is structural inequality, majority groups structure society around negative ideas about minority groups. Institutionalized majority/minority statuses distribute opportunities for success and the likelihood of failure in racially patterned ways. The dominant cultural narrative to explain failure, however, remains one of lacking fortitude, perseverance, and talent. Consequently, majority/minority racial status is best conceptualized not as population percentages but instead as the capacity of dominant groups to impose their beliefs, values, and

interpretive lens on subordinated groups in ways that minority groups cannot reciprocate. Reflecting differences in social power, status, and influence, historical processes of race-making benefit Whites and oppress populations of color.

Making Race

White narratives about opportunity and inequality dominate because of fundamental misunderstandings of what race is and how it is different from ethnicity. Race is not where people came from, what they look like, their cultural orientations, or their genetics. Race is the use of legislative, political, and policy decision-making processes to purposively and precisely differentiate, divide, and exploit human populations toward economic ends. Race was originally conceived of, brought into being, and assigned differential value to justify the material exploitation of Native Americans by appropriating historical lands through forced relocation and genocide, as well as the economic exploitation of Black Africans through chattel slavery.[1] Implying a natural hierarchy of human populations, race simultaneously assigned European immigrants to the pinnacle of the emerging social order while relegating populations of color to inferior positions. In this frame, skin color, geographic origin, and ancestry were linked to differences in desirable traits like intelligence, work ethic, and family values. Race was then and is now primarily about stolen land, stolen labor, and stolen lives but also about stolen cultures, stolen histories, and, most important for the purposes of this essay, stolen narratives.

A second group-level identity construct, ethnicity, is frequently used interchangeably with race. Ethnicity combines perceived common descent, distinctive history, and shared sets of cultural orientations.[2] Chandra Ford and Nina Harawa propose that ethnicity is a two-dimensional, social context–specific construct encompassing two dimensions: attributional and relational.[3] The first addresses unique sociocultural characteristics reflecting how groups

view themselves and the cultural orientations they develop to reflect these self-perceptions.[4] The second indexes a group's hierarchical social position and its implications for relationships with other groups, including capacity for group identity self-determination. This perspective permits consideration of ethnic identity formation within or outside the context of directly imposed racial assignment. In the United States, ethnic identity formation contends with minority racial status and works to offset and resist negative stereotypes.[5] Ethnic identity formation outside the United States reflects self-determined traditional cultural orientations that immigrants bring with them.[6]

Conflating ethnicity with race misses important differences in social outcomes. Racial minority status relegates populations of color to inferior social positions combining increased exposure to risks and restricted access to resources that reliably compromise opportunity. Ethnic identity construction, on the other hand, grants access to relatively self-determined alternative ways of being and alternate resource networks that promote opportunity (e.g., health). The degree to which ethnicity positively influences health varies contingent on whether it is constructed within (reduced) or outside (enhanced) of the U.S. context. Both those who enjoy racial majority status (Whites) and those who are classified as racial minorities (populations of color) negotiate their relative social positions through the lens of social bias and with unique cultural and behavioral responses, drawing on the resources readily available to them—and contending with the risks characterizing their positions.

Making Race Make Policy

Spanning differences in infant mortality (see chapter 12 in this volume), interactions with law enforcement (see chapter 15 in this volume), the carceral system, end-of-life care, and more, stigmatized racial bias stamps an indelible imprint on American society. A pernicious and intractable manifestation of race as policy is residential segregation. White American public

policy decision-making effectively established arrangements in which Whites disproportion-ately enjoy residential preference while populations of color contend with both forced residen-tial segregation and the negative narratives about racialized ghettos that White Americans construct and advance to explain how these groups came to be ghettoized in the first place. Of course, oppressed groups do not internalize such narratives wholesale. They engage and nego-tiate these arrangements and do so in variable ways even when similarly racialized.

Despite this, White Americans tell their own story and the stories of others. Moreover, how White Americans construct and impose oppressive responses when populations of color attempt to develop and advance their own stories is a powerful tool for determining opportu-nity, lived experience, and ultimately life and death.

FIELD MARKINGS

Vergara's photograph shows what appears to be a group of multigenerational dark and light brown people socializing in an urban setting. Boarded-up homes on a trash-laden street are telltale signs typically associated with residential segregation and urban blight. Hidden from view may be additional physical and environmental liabilities often prevalent in such commu-nities: pest infestations, environmental pollutants, decaying infrastructure, and unsafe public space. All reflect the multiple and explicit ways that racialized structural inequality compro-mises impoverished urban communities of color. While the physical condition of this commu-nity is immediately apparent, perhaps less so are the narratives that too often circulate to explain it. The trained eye sees other, more insidious, but poorly understood manifestations of inequality and human responses to it. An alternative assessment reveals social dynamics reflected in research on the physical embodiment of enforced racialization and discrimination and how ethnic identity is marshaled to deal with it.

Put simply, why would any individual or identity group, whether majority or minority, forgo the right to self-determined identity and then subject themselves to historical and contemporary social biases? The simple answer is that they would not. The individuals and groups shown in the photograph have not willfully engaged in racialized residential segregation. They, however, have developed relatively effective but not widely understood and appreciated strategies to offset and resist the impact of imposed racial minority status.

The residents pictured here appear to live in the same neighborhood and are likely to be identified as some combination of Black and Latino. The key to understanding why physical space matters for inequality in America is in unearthing how identity and social space interact with built environments. Where did residents come from? How did they arrive to those neighborhoods? How has that arrival influenced opportunities for ethnic identity construction (and racial assignment)? How have those processes influenced social interactions linked to distress? Driven by public policy decision-making, these phenomena hold important implications for social well-being, identity construction, and, by extension, health.

FIELD NOTES

Relative positions in stratified social arrangements like racial hierarchies have implications for health because these arrangements dictate access to resources for Whites and increase exposure to risks for populations of color. Moreover, populations of color benefit less from the same levels of resources that Whites hold, and Whites suffer less from similar exposure to risks than those at the bottom of the racial hierarchy.

Whether Black or Latino, being born in the United States means that individuals are constrained in forming positive ethnic identities because they live in a context of imposed

inferior racial assignment. Blacks and Latinos born outside of the United States, particularly if raised in their country of origin, enjoy benefits of ethnic identity construction independent of imposed minority racial status. The resources and risks associated with these different processes enhance or compromise health in quite different ways. Divergent paths of identity formation are influenced by policies reflecting negative perceptions of racial unworthiness and ethnic devaluation particular to U.S. society. To this point, research reveals that White Americans view foreign-born populations of color more favorably than their U.S.-born co-racial counterparts. Sadly, evidence also suggests that any advantages such views may confer are lost over time. Why?

Given structural and institutional impediments to socioeconomic success in racially segregated communities, nontraditional or non-majority-oriented social institutions may serve as relatively logical, beneficial responses to help assure the social well-being and health of targeted populations. Extended family networks, innovative economic enterprising, a sense of community membership, and mutual socioeconomic obligation are mechanisms conceived of and developed to help stave off health-compromising despair and distress. For U.S.-born Blacks, Mexicans, and Puerto Ricans, these are alternative resistant sociocultural responses. For African- and Caribbean-born Blacks as well as immigrants from Mexico and Central and South America, these are traditional sociocultural orientations constructed and brought to the United States from their countries of origin. Both orientations grant access to resources utilized to help secure social well-being and health when confronting racially motivated structural constraints. In short, similarly racialized but ethnically diverse population groups negotiate their common marginalized status differently.

The common fundamental cause driving racialized differences in health across diverse populations is toxic (dis)stress associated with minority racial status. Whether from poverty, racial and ethnic discrimination, environmental exposures, relative comparisons drawn from

inferior social positions, or combinations of these noxious exposures, stress kills. In essence, multiple and varied racialized social experiences become physically embodied and biologically embedded. They are at the heart of racialized health differences.

Two recently developed constructs directly measure the health impact of embodied and embedded racialized social distress: allostatic load measures cumulative physiological stress response in the body; telomere length measures accelerated biological aging at the level of DNA activated by toxic oxidative stress. Findings from two investigations are noted here. In the first, middle-aged Mexican immigrants with fewer than ten years in the United States had significantly better health than those with more than ten years in residence. Those with more than twenty years in residence had significantly worse health than everyone else. Additionally, these findings were not explained by differences in diet, exercise, smoking, health insurance, or health services utilization. Importantly, increases in education and income associated with a longer time in the United States predicted worse health.[7] In the second study, researchers investigating Detroit found that, as measured by telomere length, poor Whites had bad health, poor Blacks had intermediate health, and poor Latinos had relatively good health. Nonpoor Whites had significantly better health, nonpoor Blacks had the same health status, and nonpoor Latinos had significantly worse health.[8]

Several important questions emerge from these sets of findings. Why would time in the United States degrade health for Mexican immigrants despite increased education and income? Why would more education and more prestigious, better-paying jobs improve health for Whites, do nothing for Blacks, and damage health for Latinos? Several explanations pertaining to variable identity construction and interaction processes are useful for answering these questions. Ethnic density in highly segregated areas may reduce the likelihood and impact of unfair treatment, through a combination of fewer experiences in integrated settings where institutional and interpersonal discrimination are most easily perceived. These same ethnically dense areas

may provide greater opportunities for co-ethnic social ties and the identity safety and social support they provide. Such social relationships buffer members of racial and ethnic minority populations against discriminatory practices and can serve to marshal resources in the event that such practices occur. The last explanation involves the process of becoming American or, for immigrants of color, a hyphenated American.

This process brings us back to whose stories are told. Othering, the dominant group's essentializing and highlighting differences between itself and perceived socially inferior others, is a likely contributor to compromised health among immigrants of color. Over time, those who are deemed "the other" are subjected to the inequality of being differentially assigned to lower categories of a hierarchical system by both individual actors and institutions. The person or group being othered experiences this as a process of marginalization, disempowerment, and social exclusion. In this essay, the well-established U.S. racial structure is the hierarchical system of interest.[9]

Where racial minorities and the impoverished live, how they get there, how they respond to being there, and how these responses are frequently misperceived, misinterpreted, and misrepresented to the broader society by dominant groups all influence social well-being and health. Research suggests that, through multiple pathways, differences in the capacity for self-determined identity construction drives health. Ethnic identity formation and co-ethnic social ties enhance health, while imposed racial categorization, related negative social bias, and racial and ethnic discrimination all compromise health. Additional research also suggests that opportunities for healthy social interaction across racial and ethnic categories reduce the likelihood of interpersonal prejudice and discrimination, thus providing insight into what may ultimately prove to be promising avenues for intervention.

If so, public policy efforts proposing to improve the health of an increasingly diverse and dynamic broader U.S. national population should support and encourage healthy ethnic identity

construction and co-ethnic social interaction, promote opportunities for socialization across both ethnic and racial categories, and aspire to more inclusive public policy decision-making processes.

We have much work left to do!

NOTES

1 S. Cornell and D. Hartman, *Ethnicity and Race: Making Identities in a Changing World* (Thousand Oaks, CA: Pine Forge Press, 2007).

2 S. Karlsen and J. Y. Nazroo, "Agency and Structure: The Impact of Ethnic Identity and Racism on the Health of Ethnic Minority People," *Sociology of Health and Illness* 24, no. 1 (2002): 1–20.

3 C. Ford and N. T. Harawa, "A New Conceptualization of Ethnicity for Social Epidemiologic and Health Equity Research," *Social Science and Medicine* 71, no. 2 (2010): 251–258.

4 J. Y. Nazroo, "The Structuring of Ethnic Inequalities in Health: Economic Position, Racial Discrimination, and Racism," *American Journal of Public Health*, no. 2 (2003): 277–284.

5 J. A. Pearson, "Can't Buy Me Whiteness: New Lessons from the Titanic on Race, Ethnicity, and Health," *Du Bois Review: Social Science Research on Race* 5, no. 1 (2008): 27–47.

6 S. A. James, "Racial and Ethnic Differences in Infant Mortality and Low Birth Weight: A Psychosocial Critique," *Annals of Epidemiology* 3, no. 2 (1993): 130–136.

7 R. Kaestner, J. A. Pearson, D. Keene, and A. T. Geronimus, "Stress, Allostatic Load, and Health of Mexican Immigrants," *Social Science Quarterly* 90, no. 5 (2009): 1089–1111.

8 A. T. Geronimus, J. A. Pearson, E. Linnenbringer, A. J. Schulz, A. Reyes, E. Epel, J. Lin, and E. Blackburn, "Racial/Ethnic and Socioeconomic Variation in Telomere Length in

a Community-Based Sample of Detroit Adults," *Journal of Health and Social Behavior* 56, no. 2 (2015): 199–224.

9 E. Viruell-Fuentes, "Beyond Acculturation: Immigration, Discrimination, and Health Research among Mexicans in the United States," *Social Science and Medicine* 65, no. 7 (2007): 1524–1535.

1124 Broadway and
Kaighns, 1985

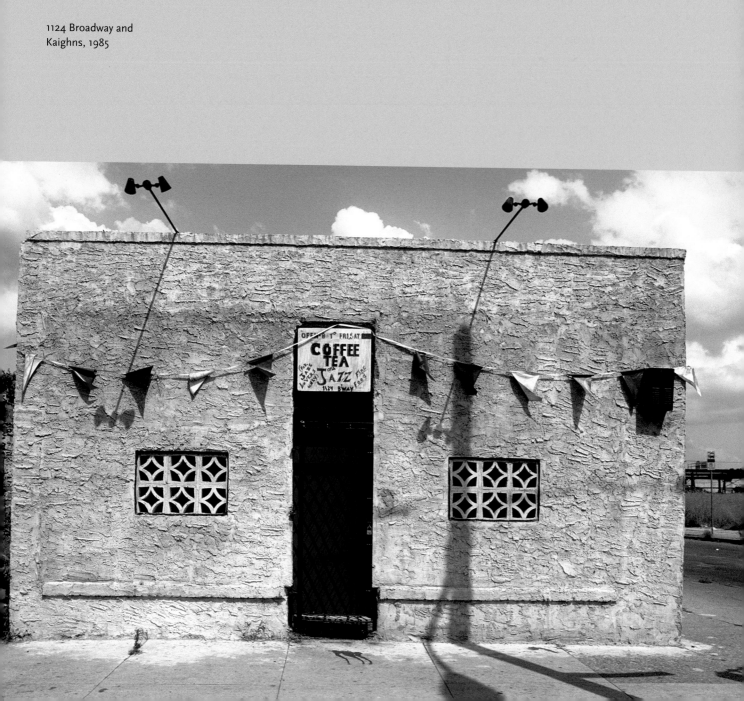

NO. 10 Disinvestment v. The People's Persistence

MINDY THOMPSON FULLILOVE

The building in this documentary photo by Camilo José Vergara is telling us two stories about American inequality. One is the story of disinvestment: the eroding of the physical space, the rising stress on people who are struggling to hold on, the narrow opportunities for success in the face of general abandonment. The other is the story of people's ingenuity, faced with nearly insurmountable constraints. Let us look first at the story of disinvestment and then return to people's tenacity.

Urban Disinvestment

What we refer to as "disinvestment" is not a single event but the cumulative effect of a long series of practices and policies, including the Cold War and its accompanying militarism, deindustrialization, urban renewal, planned shrinkage, mass incarceration, and gentrification.[1] The Cold War is rarely mentioned in studies of the American city, but it deserves extensive attention.[2] President Harry Truman was responsible for launching the Truman Doctrine and the Cold War. The Cold War had two "fronts": labor at home and the Soviet Union abroad.[3] Working people had gained power and influence by their organizing during the Great Depression. Once President Franklin Roosevelt had extended the right to organize unions, massive industrial unions formed throughout the nation. These unions fought for and won massive

extensions to the social safety net, workplace protections, and decent wages. They also organized for political power to have a voice in all the decisions affecting the country. Capital—the great industrialists and owners of other businesses—wanted both the power and the money back. To accomplish this, they launched the battle on the home front, creating a fear of "communism" that encompassed everything that spoke of people's power, from demonizing public housing projects to destroying the vanguard unions.

On the international front, the Cold War created an arms race with the Soviet Union. Military spending, which was on the decline after the end of World War II, abruptly began to rise again, never to return to the prewar level. That spending occupied a vast proportion of the nation's scientific and technical workers. Most of the innovations of the arms race offered little to solve problems of the rest of the economy, which slowly fell behind nations that kept innovating, notably Germany and Japan. Those countries, as our former enemies, were kept from rearming and thus could fully attend to industrial innovation. Japanese innovation in transistors, for example, revolutionized the radio industry, while German engineering of cameras and automobiles set the pace for those industries. As the war spending continued, American industry lost its place at the leading edge of innovation. Its products were no longer the most sought-after, and a long decline set in.

Falling behind in innovation eventually led to deindustrialization of the heavy industry cities like Camden, Newark, Pittsburgh, and Youngstown. Some of the manufacturing shifted from these Rust Belt cities in the Northeast and Midwest to the "Sun Belt" cities in the South, Southwest, and West. The shift in employment was accompanied by massive shifts in population, as many people who could move followed the jobs to the new boomtowns. Those who could not move to another place had to move to another sector of employment, a bifurcated shift to either jobs that paid well but required substantial education, or jobs that paid poorly but required little education.

The huge military budget and the Cold War had other consequences for the nation. The military budget occupies a quarter of our national spending, shortchanging other parts of the budget. Transportation infrastructure, for example, gets 2 percent of the budget, despite the fact that many parts of our transportation infrastructure are in poor repair. The grade from the American Society of Civil Engineers 2017 national report card for our bridges was C minus. As written on the organization's website:

The U.S. has 614,387 bridges, almost four in 10 of which are 50 years or older. 56,007— 9.1%—of the nation's bridges were structurally deficient in 2016, and on average there were 188 million trips across a structurally deficient bridge each day. While the number of bridges that are in such poor condition as to be considered structurally deficient is decreasing, the average age of America's bridges keeps going up and many of the nation's bridges are approaching the end of their design life. The most recent estimate puts the nation's backlog of bridge rehabilitation needs at $123 billion.[4]

The pincer of the Cold War and deindustrialization closed in on working-class neighborhoods, which were written off by the powers that be using a policy called "planned shrinkage." Human ecologists Rodrick Wallace and Deborah Wallace are the leading scholars of this process. They conducted a landmark study of the manner in which planned shrinkage led to the "burning of the Bronx" in the 1970s.[5] New York City implemented planned shrinkage by closing fire stations, which resulted in the catastrophic destruction of a massive amount of the borough's housing stock. The Wallaces documented a sharp rise in the number and devastation of residential fires. Fire in a single building would be followed by fires in nearby buildings, a process they called "contagious housing destruction." Contagious housing destruction could spread through a neighborhood, leading to loss of whole sections of the city. The cumulative

damage to the urban infrastructure they named "hollowing out of the city." In the Bronx, this led to the destruction of 50 to 80 percent of the housing stock in the southern part of the borough, followed by the spread AIDS and other epidemics, an increase in infant and maternal mortality, and a massive uptick in violence. The process of removing public and private services from working-class neighborhoods was copied by many cities, and hollowing out followed in the wake of that disinvestment.

Jobs were scarce in these battered neighborhoods, and social order was transformed. Describing what happened in the 1980s, Jeffrey Fagan and Ko-Lin Chin noted:

> The expansion of illicit drug sales in New York City has paralleled the decrease in legitimate economic opportunities in this decade. Participation in the informal economy has increased, especially among minorities living in neighborhoods where the demand for goods and services rivals participation in the formal economy. In the volatile crack markets, crack sometimes has become a "currency of the realm," a liquid asset with cash value that has been bartered for sex, food, or other goods. Sellers or users with large amounts become targets for "take offs" by either other sellers or users who want the drug. In turn, violence as self-defense is a common theme and an essential element in controlling situations in which large volumes of crack are present.[6]

The violence that accompanied crack selling triggered a massive homicide epidemic, which took off in 1985, with a slow return to baseline levels. In that period, homicide became a major cause of death among young African American men. Rather than institute public health measures to respond to the problems that had caused the drug-based economy, politicians sought to punish its participants, instituting "War on Drugs" policies, among them, mass incarceration. The prison system, like the military system, requires enormous amounts of money: according to

a 2016 analysis by the U.S. Department of Education, state and local spending on incarceration had grown three times as much as spending on education since 1980. The prison system affects a massive number of people: in 2016, a total of 6.6 million people were incarcerated or under supervision in the community. The incarceration of so many people has a disastrous effect on communities, families, and the economy. Because people who have been incarcerated are denied a panoply of rights—including voting, housing, education, and travel—they are confined to very small parts of the city and the economy. It is impossible for many to avoid a return to a life of crime. Others struggle, unable to access all the resources of the city or to participate fully in the life of the community. Incarceration's permanent stigma on individuals undermines the integrity of the whole urban ecosystem.

People's Persistence

We also learn from this building about people's persistence. In spite of deindustrialization knocking the economic foundation out from under them, planned shrinkage destroying their social foundations, and government showing up to punish rather than support, people keep trying. We read that in the flags and the sign that says, "Coffee, Tea, Jazz, Fine Food." It has become popular to talk about this as "resilience," but that word is too facile and is often used to discount the heavy toll that these decades of disinvestment have taken on the health and well-being of the people. "They're resilient" is used to mean, "If people can still try, then they were not harmed." In fact, there is evidence that injuries of all kinds cause lasting harm, which become manifest as increased morbidity and early mortality. Consider the case of the football players, who rise from the field after a blow to the head. In the moment, they look "resilient," but we can see the costs as time goes by and they suffer and die young from blows to the head sustained during their playing years.

FIELD MARKINGS

We see a building in isolation, holding the fort with its banners and its purpose. A square, flat-roofed, single-story building, with gray stucco, two windows filled with decorative concrete blocks, some "grand opening"–type flags across the top, and a hand-painted sign above the door that advertises "Coffee, Tea, Jazz, Fine Food." Background to the right: a street, and then grass, where I would think another building should be. What are we to make of the "Coffee, Tea, Jazz, Fine Food" promised by the awkward handmade sign?

The exterior is not promising, to my eye. The stucco exterior and barricaded windows close the interior off from my inspection—what would I be getting into if I entered? I would expect the interior to be as patched together as the exterior. I have been in lots of places like that: places that have not seen investment in many decades, perhaps since the factories closed, good jobs disappeared, and working people's wages stopped rising.

The bedraggled demeanor, however, should not be taken as a statement about the reception I might get if I entered, or the quality of what the people who are making the place have produced. There are people of many talents who live in Camden and are struggling to make a way for themselves. Some of the best soul food in America is served up at Corrine's, a mile away. And I once visited Santana's, a Hispanic bakery that made a place for itself in Cramer Hill with the help of the neighborhood. The bakery got its start when someone discovered a used oven for sale, someone else had a truck, and a lot of strong friends agreed to go on the trip to get the oven for the bakery-to-be. Their bread was mouth-wateringly good. I have not encountered musicians in Camden, but I am sure it is the same thing: lots of people play an instrument and draw sustenance from playing together. In sum, all of what is promised by the sign might be very fine, indeed. I would have to ask, or try my luck, to get to the bottom of the matter.

FIELD NOTES

Such a small building on Main Street, weary from time and lack of investment, holds a story that we need to understand. I have been studying Main Streets for ten years. In the course of that time I have walked Main Streets in 142 cities, some of them often, some only once. My quest was to understand how Main Streets were related to mental health in our society.[7]

I fell into this research project accidentally. I grew up in Orange, New Jersey, which had three wonderful Main Streets. As time went on, and those Main Streets sagged, I bemoaned the closing of the movie houses, the loss of the great stores, and the creeping tawdriness. I thought of it as the death of Main Street. Then one day I was sitting in Starbucks, located on a sunny, south-facing corner on Palisades Avenue in Englewood, New Jersey. I was looking out the big windows and noticed there was a lot going on outside. "Wait," I thought to myself. "Isn't Main Street dead?"

As it turns out, throughout New Jersey there are vibrant Main Streets, filled with bustling stores, adorned with civic buildings and monuments, and inhabited by people with lots of projects on their minds. The ensemble of buildings, public space, and destinations of civic importance creates a center for public life that both stabilizes and enriches the surrounding community.

But not all Main Streets are in good shape. Broadway in Camden, once as beautiful as any Main Street in the state, has fallen into a state of desuetude, its allée structure broken, its embedding context disintegrated, and its ability to do its work diminished. Which might lead us to ask: Did people in Camden not make an effort? Is that why their city fell apart? The answer is that their city fell apart because of decades of the policies outlined here: McCarthyism, the Cold War and militarization, urban renewal, planned shrinkage, and disinvestment. That there is anything standing—Corinne's, Satana's Bakery, this fine food establishment—is

testament to what people are able to do in spite of the odds being stacked against them. It is also incontrovertible that they are paying a heavy price. Like the football players, the injuries from all these policies have lingering effects, and the residents of a battered city pay, as the football players pay, in increased illness and early death.

Thus, we need a more sophisticated understanding of "still trying." No species would survive if there were not a "life instinct," a powerful force pushing its members to keep making an effort. In the aftermath of the 9/11 attacks on New York City, I observed one significant part of this life instinct at work in people: a huge proportion of the population felt compelled to "do something." At first, huge lines formed for people to give blood, then people gave money, then they started or joined organizations and events. They helped with cleanup at the risk of their own health. They participated in envisioning the future. These activities came at a cost to the population. They took time and money away from other activities. But the investment in rebuilding was a massive push to repair the city and its population, seen as an essential precursor to the success of other efforts. The rebound of New York is a testament to people's urge to "do something."

The people's will to survive and make a better place is our greatest asset. It will be much needed in the decades to come, as we face the upheavals of climate change layered on top of all of our other challenges. It is not resilience, which is used to minimize harm, but persistence that we can count on. With foresight, we might nurture it, sustain it, and protect it, as the core asset that it is.

NOTES

1 Mindy Fullilove and Rodrick Wallace, "Serial Forced Displacement in American Cities, 1916–2010," *Journal of Urban Health* 88, no. 3 (2011): 381–389.

2 Rodrick Wallace, Deborah Wallace, J. E. Ullmann, and H. Andrews, "Deindustrialization, Inner-City Decay, and the Hierarchical Diffusion of AIDS in the USA: How

Neoliberal and Cold War Policies Magnified the Ecological Niche for Emerging Infections and Created a National Security Crisis," *Environment and Planning A* 31, no. 1 (1999): 113–139.

3 Ginger Ann Fagan and Christiano David, *The Cold War against Labor: An Anthology*, ed. Civil Liberties Institute (Berkeley, CA: Meiklejohn Civil Liberties Institute, 1987).

4 American Society of Civil Engineers, "Bridges: Infrastructure Report," accessed December 21, 2018, https://www.infrastructurereportcard.org/cat-item/bridges/.

5 Deborah Wallace and Rodrick Wallace, *A Plague on Your Houses: How New York Was Burned Down and National Public Health Crumbled* (New York: Verso, 1998).

6 Jeffrey Fagan and Ko-Lin Chin, "Violence as Regulation and Social Control in the Distribution of Crack," in *Drugs and Violence: Causes, Correlates, and Consequences,* ed. M. De La Rosa, E. Lambert, and B. Gropper (Washington, DC: National Institute on Drug Abuse, 1990), 8–43.

7 By the end of my study of Main Streets, I had visited Main Streets in 178 cities in 14 countries. Mindy Thompson Fullilove, *Main Street: How a City's Heart Connects Us All* (New York: New Village Press, 2020).

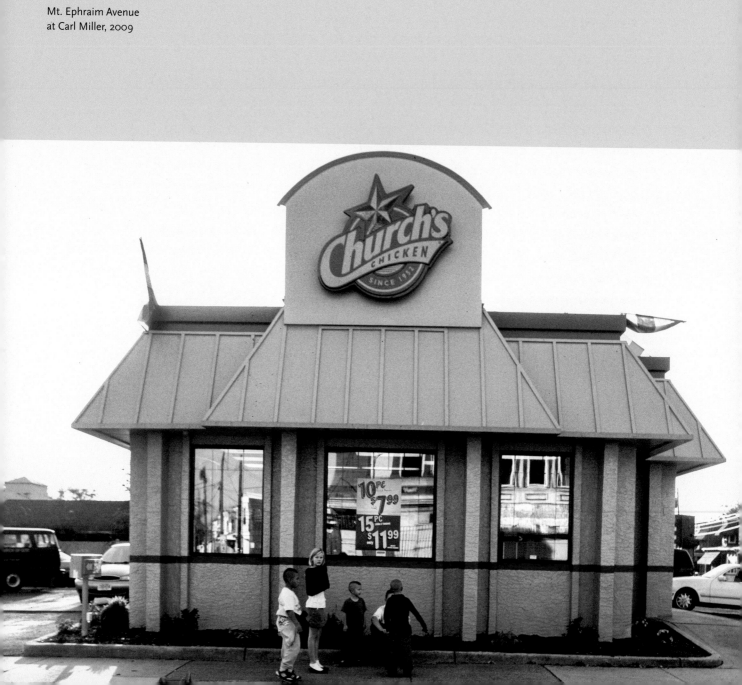

Mt. Ephraim Avenue
at Carl Miller, 2009

NO. 11 Racial Patterning of Fast Food

NAA OYO A. KWATE

Fast food needs no definition. America's national food, hamburgers and French fries define a global imaginary of U.S. restaurant dining in the modern era. Ironically, despite the fact that "American" is racially coded as "White," fast food in urban contexts has for several decades been shaded as Black. In urban settings, fast food is often most prevalent in neighborhoods that are predominantly Black, and these patterns are not explained by income, consumer demand, or other population characteristics. Evidence on the disproportionality of fast-food exposure has typically come from public health and preventive medicine, and the analysis has therefore been motivated by questions about obesity, diet, and chronic disease. If Black neighborhoods contend with higher densities of fast food, then they face unequal health risks.

Is that how we should think about fast food as an exemplar of American inequality? Is fast food first and foremost toxic—its calorie-laden, nutrient-lacking, mass-produced food a source of illness and the perpetuation of health disparities? Or ought we reconsider our definitions of toxicity? What of the urban divestment that is often prelude, if not prerequisite, to fast-food siting? What social and economic harms are wrought beyond the promotion of foods that are bad for you? Fast-food restaurants perched on Black neighborhood street corners are laden with historical and contemporary injustices. Fast food belongs in a field guide to inequality because it represents and connects many aspects of urban inequality, including the flight of capital, problematic aesthetics in the built environment, and the perpetuation of racial stereotypes.

FIELD MARKINGS

We may read inequality variously in this photograph of a Church's outlet at the corner of Mt. Ephraim and Carl Miller. First: *the flight of capital.* Fast food proliferates when public and private actors withhold, retract, or prevent capital investment. When other retailers eschew Black space, more room exists for fast-food outlets to take root—a condition evident in this photograph. At the time it was taken (2009), the restaurant appeared bereft of retail neighbors, an orphan in what should be a busy commercial strip. To be sure, the fast-food industry prizes corner locations, profiting from their high visibility and foot traffic, and so we should not necessarily expect to find Church's midblock among other stores. Nevertheless, fast-food outlets in the close quarters of an urban grid are typically proximal to other establishments, however characteristic of the typical concatenation of retail that signals American apartheid (e.g., check-cashing outlets, liquor stores). The sea of asphalt in which Church's is ensconced here may act as a moat for pedestrians, but it is a precondition for drive-thru automobile traffic.

This Church's came into being in a community where there was room to build. Room to build exposes the flight of capital. In the years immediately preceding the current photograph, the restaurant was the abandoned relic of a previous fast-food incarnation, faintly reminiscent of a spaceship, gray and hulking, with naked flag posts weaponizing the roof. In the years following Vergara's photograph (by 2017), the restaurant was once again closed, the failed enterprise now penned in by chain-link fencing, and a crude advertisement spray-painted on boarded doors: "FOR RENT 267 4842".[1]

Note also the plate glass windows; mirror-clean, they sparkle with abandonment, reflecting the decay of unoccupied buildings across the street. As is so often the case, fast food goes where other retail corporations fear (or deign not to) to tread. This lonely Church's, confronted with and perhaps attracted by physical disorder, reflects location siting algorithms that extend beyond consumer expenditures on restaurant dining. No, fast food is not attracted solely by

disorder—outlets also exist in upscale suburban White space, often holdovers from an earlier epoch when fast food was a marker of exclusivity and modernity rather than lowbrow tastes. But, the key point here is that fast food follows the color line within city limits, not that it fails to venture beyond them. Suburban restaurants are often chains, and those chains may be fast food or fast casual, but rarely are they Burger Kings and KFCs; they are Starbucks, Chipotle, or other brands less stained by the reputation that the old standards have. Old fast food is Black. New fast food is White.

The perpetuation of racial stereotypes. This Camden restaurant looks new. This too is a field marker that tells us where we are, because a new fast-food restaurant in urban space in 2009 means that this is a Black or Latino neighborhood. Old-school fast-food outlets—selling fried chicken to boot—are not built anew in White space. Fast food in White space is trendy, priced for the affluent, and in some cases led by celebrity chefs. For example, Shake Shack, founded by New York City restaurateur Danny Meyer, markets high-quality products and courts "foodie" sensibilities, stoking nostalgia for an era of modest roadside stands that Black consumers were unable to patronize. From the website: "In 2004, a permanent kiosk opened in the park: Shake Shack was born. This modern day 'roadside' burger stand serves up the most delicious burgers, hot dogs, frozen custard, shakes, beer, wine and more. An instant neighborhood fixture, Shake Shack welcomed people from all over the city, country and world who gathered together to enjoy fresh, simple, high-quality versions of the classics in a majestic setting. The rest, as they say, is *burger history.*"[2]

But the actual classics are familiar, and familiarity breeds contempt. Without the sheen of high prices, Shake Shack's menu would be too much like the anachronisms served in Black neighborhoods. The Church's at Mt. Ephraim and Carl Miller, like other common fast-food joints, are not meant to welcome a world citizenry, do not organize their menus around fresh, high-quality ingredients, and would not pretend to majesty in their design. As one manager of a reportedly dingy and cramped Cincinnati Fried Chicken on 125th Street in Harlem put it,

"I have never figured out why these people keep coming here like crazy. My chicken is heavy and greasy and I can't afford to put in air conditioning like Kentucky Fried Chicken. I guess it's just that cheap."[3] In this case, Cincinnati Fried Chicken, like the other marginal fast-food establishments that dot Black space in New York City, is a step below even the despised mainstream chains. Fast-food outlets like these understand blackness to be coextensive with a market motivated above all by an inexpensive menu. The food need not be tasty, nor must customers be treated with respect.

For industry commenters, racial stereotype in fast food is common sense: "There is no better place to sell chicken than on a busy thoroughfare in a predominantly black neighborhood bordering blue-collar South Philly." So said a report about the expansion of fast-food, and specifically, fried chicken chains, at the corner of Broad and Christian Streets in 1982.[4] Taking as received wisdom that Black people are the staple market, the newspaper's analysis projects a linkage between fast food and blackness as sound business planning. In contrast to "blue-collar" (read: White, male, working-class) Philly, Black residents lack class position, an undifferentiated aggregation of mouths hungry for fried chicken. Stereotypes of Black people as obsessed chicken-thieving scoundrels have been endemic in the American imaginary, and this newspaper account continued that narrative.[5] South Philly's chicken corridor sat at the junction of three census tracts, two of which (east of Broad Street), were hardly Black, at 45 percent and 16 percent of the population. The third, on the other side of the street, was 98 percent Black and abutted another that was a mere 5 percentage points lower.

If the group of fast-food restaurants sought out those who lived to the west of Broad and Christian, they mirrored the national market in aggressively courting Black consumers. One of the South Philly contingent was Church's Fried Chicken. More than thirty years later, it is no longer, victim to changing neighborhood demographics. In an area now called Graduate Hospital, the tract that was 98 percent Black in 1980 was 41 percent Black in 2010, and the

neighboring tract fell from 93 percent to 26 percent. East of Broad, already moderate numbers fell further (from 45 percent to 19 percent Black). Fast food tends to be less stable over time than some of the other retail categories that pervade Black neighborhoods (e.g., liquor stores). However, at least in Chicago, when a fast-food restaurant closed down, it was more likely to be supplanted by yet another fast-food restaurant or liquor store, suggesting that in many instances, the more things change, the more they stay the same.[6]

Church's Fried Chicken has since at least the late 1960s sought out Black customers; Latino communities came under its gaze in later years. Today, racial stereotype is embedded in franchise offering materials. The website features Black and Brown individuals and families to illustrate the company's "Brand Positioning," described thusly: "In 2013, we refined our brand positioning so it appeals more to people who flat out love chicken—or what we call 'Chicken Passionates.' These people come from all walks of life and typically choose to eat chicken 4–6 times a week." The document further describes the company's menu as "designed to resonate with the country's fastest growing demographic—multicultural consumers." Most fast-food chains came late to the "hood," and racial targeting reflected a host of social, economic, and cultural circumstances that shifted corporate attention from exclusively White space. Unlike these major chains, Church's seems to have had racial and ethnic targeting as its raison d'être.

Problematic aesthetics. Urban inequality is thrown into bold relief vis-à-vis the quality of the aesthetics in the built environment. Urban design choices reveal much about the valuation of Black communities. At first blush, to characterize the aesthetics of this restaurant as problematic may seem misplaced. Its cheerful yellow facade and house-like form radiate warmth, particularly set against a backdrop of impervious surfaces. But where is the front door? Oriented primarily to vehicles in a community where most will not own one, the restaurant is a sort of trompe l'oeil, simultaneously beckoning and rejecting passersby. Missing, hidden, barred, or buttressed doors prepare retail in Black space for criminal onslaught; at a fast-food restaurant,

they undo messages about the homey domesticity that imbues the meals served. Why has the directive "NO PARKING" been permanently stenciled on the sidewalk? The admonishment anticipates social incivilities either real or perceived, and suggests the community is problematic.

At least this Church's is obviously a restaurant. That is, it stands in contrast to the unmarked bunkers so often scattered across Black space. Many ramshackle fast-food outlets on Chicago's South Side, for example, are but a segment of contiguous brick facades, broken intermittently by windows covered in steel bars and industrial metal mesh, and indistinguishable from their neighbors.

FIELD NOTES

While Church's was battling out chicken competitors in South Philly in the early 1980s, urban legends about a nefarious plot for racial domination circulated regarding its chicken. Church's was not the only fast-food chain to be affected by rumor: McDonald's reportedly sold hamburgers contaminated with worms; Arby's meals were supposedly peppered with buckshot; Pizza Hut was thought to sell dog food; and KFC allegedly sold fried rats. In the last, the story went that a young couple was out on a date at the movies, enjoying a bucket of chicken, when the girl became violently ill and was rushed to the emergency room, where she died of strychnine poisoning. Upon inspecting the bucket of chicken, the boy discovers that in fact one of the pieces of poultry was a battered and fried rat. These legends may find their genesis in the nature of the fast-food industry. According to Gary Alan Fine, these corporate businesses are outside entities whose interests are not synced with communities, and whose employees might therefore serve contaminated food due to recklessness, negligence, or deliberate sabotage. Urban legends about restaurant chains reflected anxieties and guilt about eating mass-produced,

potentially unclean food from outside the home. It was perhaps the 1970s notion of "future shock," wherein people have difficulty adapting to technological change.[7]

But would the same societal changes explain the legend that Church's Fried Chicken was owned by the Ku Klux Klan, and that its chicken was poisoned so as to sterilize Black male customers? Unlike the Kentucky fried rat, the account about Church's did not describe a discrete incident and did not have a narrative element; it was presented as simple fact, an ongoing threat without closure.[8] In Patricia Turner's research, Black respondents from East Coast cities were particularly aware of the rumor, while White counterparts were largely unaware of it, unless they maintained close social relationships with Black folk. Informants found it credible that the Klan could deploy a conspiracy of this magnitude, and that it could bypass expected state controls such as the Food and Drug Administration. The etiology of the rumor? Several aspects of Church's operation were viewed with suspicion. For one, the menu served items similar to a soul food restaurant, such as fried okra, corn on the cob, and catfish. As well, the folk assumption behind the company's lack of advertising was that there must have been something to hide.[9]

Indeed, among Chicago newspapers in one historical newspaper database—the *Chicago Tribune* and six other smaller newspapers catering primarily to White audiences—I could not find a single advertisement (excluding employment classifieds) for the restaurant between 1952 and 1986. The *Chicago Defender*, the largest entity among the national Black press, ran at least two advertisements in 1972 and 1973. These listed seventeen locations, overwhelmingly in Black neighborhoods, or on the border of Black space. Some of the restaurants were in communities that were once White, while others could only have been constructed deliberately in Black neighborhoods. Church's heavy presence in Black neighborhoods was the third reason that Black people found credible rumors of a nefarious plot of racial extermination.[10]

The Klan rumor hints at a final reason why fast-food restaurants belong in a field guide to inequality: because Black residents see them as markers of such. High fast-food density reveals

the competing tensions that bedevil Black participation in American consumerism. Redlined for a broad range of other restaurants, but chastised for patronizing that which is available (fattening fast food), Black communities contend with irreconcilable retail differences. Other than liquor stores, few other retail categories incite the same suspicion and concern from Black urban residents. Both fast food and liquor stores have been the subject of vigorous community protest and actions to address the inequities in their distribution, historically, and in the contemporary moment. Legislation such as the ban on additional fast-food restaurants in South Los Angeles (formerly known as South Central) is but one example of how Black and Brown communities have conceptualized and challenged racial injustice—and reveals that fast food keenly illustrates much about how we ought to think of inequality in America.

NOTES

1 Camilo José Vergara, "Invincible Cities," Rutgers University, accessed October 24, 2013, http://invinciblecities.camden.rutgers.edu/intro.html; street view, Google Maps, accessed June 11, 2018, http://maps.google.com/.

2 "Our Story," Shake Shack, accessed October 6, 2020, https://www.shakeshack.com (emphasis in original).

3 Alix M. Freedman, "Habit Forming: Fast-Food Chains Play Central Role in Diet of the Inner-City Poor," *Wall Street Journal*, December 19, 1990.

4 "The Fast Food Front," *Philadelphia Inquirer*, July 4, 1982, accessed February 5, 2018, http://www.newspapers.com.

5 Psyche A. Williams-Forson, *Building Houses out of Chicken Legs: Black Women, Food, and Power* (Chapel Hill: University of North Carolina Press, 2006).

6 Naa Oyo A. Kwate and Ji Meng Loh, "Fast Food and Liquor Store Density, Co-tenancy, and Turnover: Vice Store Operations in Chicago 1995–2008," *Applied Geography* 67 (2016): 1–13.

7 Gary Alan Fine, "The Kentucky Fried Rat: Legends and Modern Society," *Journal of the Folklore Institute* 17, no. 2 (1980): 222–243.

8 Patricia A. Turner, "Church's Fried Chicken and the Klan: A Rhetorical Analysis of Rumor in the Black Community," *Western States Folklore Society* 46, no. 4 (1987): 294–306.

9 Fine, "Kentucky Fried Rat."

10 Fine.

SAFETY AND SECURITY

Elm and Front
Streets, 2000

CHESAPEAKE

Your chances of losing
your newborn baby are twice those
of a white woman.

Let's save our future.

Black Infants · Better Survival 1·888·414·BIBS

A message from The New Jersey Department of Health and Senior Services
Christine Todd Whitman, Governor

NO. 12 Persistence of Black/ White Inequities in Infant Mortality

KELLEE WHITE

Infant mortality is widely considered to be a benchmark of a society's overall health. More than a marker of child and maternal health, it reflects the biological embodiment of social and economic inequities and the unrealized potential of populations disproportionately burdened with poorer health outcomes.

Racial inequities in infant mortality and other birth outcomes (i.e., preterm birth, low birth weight, very low birth weight, and fetal mortality) are well documented. According to the Centers for Disease Control and Prevention (CDC), infant mortality rates in 2016 were 11.4 deaths per 1,000 births for Black infants and 4.9 deaths per 1,000 births for White infants.[1] In other words, African American women are more than twice as likely as White women to have an infant die before it reaches its first birthday. The consistently higher risk among African American women, in comparison to White women, holds regardless of socioeconomic status.[2] Traditional risk factors such as low income or educational attainment, lack of health insurance, inadequate prenatal care utilization, medical risk factors, and maternal health behaviors (i.e., smoking, alcohol use, diet, and exercise) do not fully explain the observed inequities. In fact, it has been estimated that these factors account for less than 40 percent of variation in infant mortality between African American and White mothers.[3]

Despite overall improvements in reducing poor birth outcomes among mothers in the United States, progress toward closing the racial gap has been underwhelming. These pronounced

racial differences in infant mortality, which have persisted for more than half a century, have actually worsened in some areas.[4] In an effort to further understand why race continues to be a fundamental determinant of poor birth outcomes, some researchers have focused on circumstances in the daily lived experience of African American women that extend beyond health care. African American mothers have a heavier burden of social, economic, and environmental stressors. For example, in comparison to White women, African American women are more likely to report experiences of racial discrimination. African American women are more likely to reside in neighborhoods that are highly segregated communities with pockets of concentrated poverty and higher exposures to environmental pollutants in the form of toxic waste dumps, car emissions and noise from freeways. Eliminating racial disparities in birth outcomes cannot be separated from redressing racial inequities in educational and employment opportunities, neighborhood context, and the criminal justice system that shape the daily experiences and opportunities across the life course of women, children, families, and communities.

FIELD MARKINGS

This billboard alongside a Camden grocery store is an explicit representation of inequality in that it expresses one in the text: "Your chances of losing your newborn baby are twice those of a white woman." These words reflect one of the most consistent, pernicious, and enduring truths of health inequalities in the United States—race is foundational in life and death in this country. Note also the timing of the message in the billboard. One can just barely see in the lower right-hand corner of the photo that Christine Todd Whitman was governor of New Jersey. Todd Whitman served as governor from 1994 to 2001. More than fifteen years later, the statistic quoted in the photo remains true. Indeed, this billboard could have just as easily

appeared in 1979 or 2019 with the same figures. Unfortunately, improvements in racial differences in key child health indicators such as infant mortality have stalled.

The billboard appears to be part of a public health educational campaign directed at raising awareness and concern in a community about racial differences in infant mortality and targeting mothers to improve outcomes for their infants. It presents an image of a mother and her baby enjoying a tender, joyful, and loving moment together. However, to depict the mother alone is to connote the primacy of "mother" as the most important—indeed culpable—in infant health and mortality. While the individual choices of mothers can mitigate or potentiate risk for adverse birth outcomes, there are other reasons that contribute to the observed disparities. This image also affirms the orientation to personal responsibility that pervades biomedical approaches to health care and many infant mortality health interventions, programs, policies, and priorities. Yet, the structural inequality and neighborhood social and economic context that play a major role in generating infant mortality disparities are not evident.

"Let's save our future" connects the unequal beginnings of Black babies' lives with poorer health conditions during adulthood. Studies have shown that babies who are born preterm or at low birth weight are more likely to have health problems throughout their lives. The short-term effects may include lengthier hospital stays and developmental complications during infancy and childhood. There is also mounting evidence that there are long-term health ramifications for heightened risk of an early onset of chronic diseases, such as diabetes, hypertension, or cardiovascular disease later in life. Moreover, data are available that link women who were born preterm to increased risk of gestational diabetes, gestational hypertension, or pre-eclampsia during pregnancy.[5] The higher likelihood of chronic diseases and pregnancy complications may lead to a higher proportion of excess deaths—those deaths that are preventable through public health resources that support healthy behaviors and strengthen access to the health care system—among African American women.

"Let's save our future" is also a call to arms to address infant health inequities. It can be interpreted as emboldening readers of the billboard to believe that one has agency—the power to change current and future health effects of adverse birth outcomes. The billboard is also an encouraging appeal that bolsters the agency of women by empowering them to believe in their ability to change the tide of health inequities. That is, the ad promotes a subtle message about women being equipped to leverage their skills, resources, and support systems to minimize their own health risk and that of their infants. It may also persuade others to mobilize to advocate for, and build support to act to improve the life chances of Black babies. The proactive engagement of women, families, advocates, and communities about their role in protecting infants, in tandem with addressing structural barriers, can enhance efforts that advance strategies and policies to reduce infant mortality disparities.

The billboard also implicitly expresses American inequality by what is noticeably absent from the picture. Where are the vital sources of support that women need for a healthy pregnancy? Fathers (or co-parents), families, communities, and health-care professionals are important sources of emotional, psychosocial, financial, and informational support. In the photo, the mother's left hand is visible, and she appears to wear a wedding band. Some studies have found an association between the lack of paternal involvement, the absence of a father's name on the birth certificate, and poorer infant morbidity and mortality outcomes. African American women who are single are more likely to encounter stereotypes and stigma from health-care providers regarding their marital status. Women, regardless of marital status, need strong sources of positive support during the antenatal and perinatal periods, and this type of support is prominently missing from the billboard. The lack of a social support system for mothers and their infants is stressful and can negatively impact health. Stressful life circumstances combined with stressful neighborhood conditions, such as lower socioeconomic status, higher rates of violent crime, and higher levels of social and physical disorder, can make women more vulnerable to giving birth to low-birth-weight or preterm infants.

We have ample evidence about what women need to access and receive optimal care. First, reproductive health-care services, providers, and facilities should be located proximally in communities. Second, these services should provide patient-centered and culturally sensitive care. Patient-centered reproductive health care is respectful of and responsive to a woman and her family's preferences, needs, and values throughout the clinical interactions, decisions, and treatments.[6] Also, culturally sensitive care ensures that providers are aware of the ways in which implicit bias in patient encounters interferes with treatment decisions, and the quality of communication between patients and providers, so that patient dissatisfaction and medical distrust are prevented. Developing initiatives that aim to strengthen the reproductive social capital of women, support African American families, invest in communities, and improve the health-care system services and provider interactions is crucial to reversing the effects of social inequality on the health of African American babies and mothers.

FIELD NOTES

Addressing the racial gap between African American and White women's birth outcomes continues to be a significant public health and clinical priority. Although the infant mortality rate decreased by 13 percent from 2000 to 2013, overall trends in racial disparities persist and in some geographic areas are worsening.[7] African American women fare little better than their infants. They have worse maternal morbidity and more serious challenges associated with postpartum care; according to the Centers for Disease Prevention and Control (CDC), they are three to four times more likely to die than White women from pregnancy-related complications. Although racial disparities in risk factors related to pregnancy and preexisting disease conditions (e.g., hypertension and gestational diabetes) exist, there is increasing attention given to the role of the social, economic, and structural determinants of health as primary

drivers of disparities in adverse maternal morbidity and mortality. Many of the maternal deaths, pregnancy-related complications, and comorbidities are preventable. However, these outcomes are exacerbated by women's experiences of stress from racism and discrimination that contribute to poorer health outcomes.

Recently, high-profile stories have appeared in the media of women who died during pregnancy or who survived near-death pregnancy-related complications, including world-renowned tennis player Serena Williams and Dr. Shalon Irving, a lieutenant commander in the U.S. Public Health Service Commissioned Corps and an epidemiologist at the CDC. Their experiences illuminate the challenges and failures of the health-care system that are frequently encountered by Black women. Affluence, education, high-prestige occupations, and even global celebrity do not protect Black women from being ignored, dismissed, or not taken seriously by their providers when they raised concerns about their health symptoms during pregnancy. Dr. Irving's example is particularly disheartening. She had a distinguished career dedicated to addressing and eliminating racial and ethnic health inequities and was vigilant in her own health care throughout her pregnancy. When she expressed concern about her health, "her complaints were not adequately addressed and routinely dismissed," according to her mother, Wanda Irving. Tragically, Dr. Irving died three weeks after giving birth to her daughter Soleil. Dr. Irving's mother, said: "Black women are not seen or heard when it comes to their health, especially during and after pregnancy." Averting preventable maternal deaths and improving maternal outcomes that contribute to disparities is achievable if the voices and interests of African American women are elevated.

Prenatal care typically focuses on maternal health during the nine months leading up to the pregnancy. However, a life course perspective recognizes birth outcomes are a consequence of maternal health—before, during, and after pregnancy—and exposure to social, economic, and environmental stressors across a woman's life span. The two life course theories most relevant

to infant and maternal outcomes are early (fetal) programming and cumulative pathways (weathering). The fetal programming theory posits that in utero exposures to injury or stress can determine physiological and metabolic responses in adulthood. For example, studies have found that in utero exposure to neighborhood poverty can lead to the delivery of a low-birth-weight infant or result in epigenetic changes that last across generations.[8] A cumulative pathways mechanism proposes that chronic stress responses and allostatic load over the life course can result in poorer reproductive health and accelerated aging.[9] In this regard, Arline T. Geronimus has attributed Black-White differences in maternal and infant health to "weathering," the cumulative impact of social and racism-related stress on the deterioration of Black women's reproductive health and ultimately infant health.[10] African American women's greater likelihood of experiencing a longer exposure to this stress explains in part some of the observed differences between Black and White women in giving birth to infants who are preterm, of low birth weight, or small for gestational age. The combined intergenerational legacy of racism and the inequitable distribution of social, economic, psychosocial, and environmental risk over one's lifetime ultimately lead to the observed racial disparities in maternal and infant mortality.

If we are to reduce infant mortality, we must leverage the resilience of communities and develop novel approaches that go outside of the traditional boundaries of medical care. Intensified efforts to educate women on the well-documented individual-level behavioral and medical risk factors fail to change the course of disparities and only lead to incremental progress in eliminating disparities. In many states and local municipalities, infant and maternal health disparities are being flagged as a legislative priority that focuses on collective impact and community-level partnerships. Such strategies are needed to fully address the complex causes of adverse birth and maternal outcomes. Achieving optimal and equitable infant and maternal outcomes for African American women, children, families, and communities requires

addressing and targeting the structural inequalities that create, contribute to, and reinforce health injustice.

NOTES

1 Department of Health and Human Services, Centers for Disease Control and Prevention, National Center for Health Statistics, Division of Vital Statistics, *User Guide to the 2016 Period Linked Birth/Infant Death Public Use File* (n.p.: Department of Health and Human Services, 2016).

2 S. A. Lorch and E. Enlow, "The Role of Social Determinants in Explaining Racial/Ethnic Disparities in Perinatal Outcomes," *Pediatric Research* 79, no. 1 (2016): 141–147; N. Matoba and J. W. Collins, "Racial Disparity in Infant Mortality," *Seminars in Perinatology* 41, no. 6 (2017): 354–359.

3 J.S.B. Speights, S. S. Goldfarb, B. A. Wells, L. Beitsch, R. S. Levine, and G. Rust, "State-Level Progress in Reducing the Black-White Infant Mortality Gap, United States, 1999–2013," *American Journal of Public Health* 107, no. 5 (2017): 775–782.

4 N. Matoba and J. W. Collins, "Racial Disparity in Infant Mortality," *Seminars in Perinatology* 41, no. 6 (2017): 354–359.

5 T. M. Luu, S. L. Katz, P. Leeson, B. Thebaud, and A. M. Nuyt, "Preterm Birth: Risk Factor for Early-Onset Chronic Diseases," *Canadian Medical Association Journal* 188, no. 10 (2016): 736–740.

6 M. Sudhinaraset, P. Afulani, N. Diamond-Smith, S. Bhattacharyya, F. Donnay, and D. Montagu, "Advancing a Conceptual Model to Improve Maternal Health Quality: The Person-Centered Care Framework for Reproductive Health Equity," *Gates Open Research* 1 (2017): 1–14.

7 Speights et al., "Reducing the Black-White Infant Mortality Gap."

8 Speights et al.

9 M. C. Lu, M. Kotelchuck, V. Hogan, L. Jones, K. Wright, and N. Halfon, "Closing the Black-White Gap in Birth Outcomes: A Life-Course Approach," *Ethnicity and Disease* 20, no. 1 (2010): 62–76.

10 A. T. Geronimus, "The Weathering Hypothesis and the Health of African-American Women and Infants: Evidence and Speculations," *Ethnicity and Disease* 2, no. 3 (1992): 207–221.

327 Stevens Street

NO. 13 Urban Childcare Dilemmas

JANICE JOHNSON DIAS

Poor urban working parents are often forced to choose among limited and inadequate options for quality childcare. Constrained by their economic realities, parents elect care centers using a calculus largely based on their meager income. The product of this calculation prioritizes their children's personal safety over their emotional and physical well-being. In so doing, parents inadvertently place their most precious resources—their children—in nurseries and childcare centers that can unintentionally hamper their socio-emotional development and physical health. The location, physical settings, and architectural layout of low-income childcare centers too often serve to confine and arrest children's bodies and minds.

Approximately 75 percent of all U.S. children under the age of five are in some form of non-parental care. Furthermore, more than 50 percent of mothers return to work within a year after giving birth.[1] The majority of these parents are not affluent and rely on income from work to provide for their family. Participation in the workforce means that parents must consider where and with whom they will seek care for their children.

For highly resourced and economically endowed parents, this decision is often an emotional choice between family care or high-quality private care outside of the home. Affluent parents can use their buying power to secure quality care for their children; they merely have to decide which setting works best for them. These parents of means can assume that their children will be safe; they can therefore think of much higher-order matters such as their and

their children's overall happiness, as well as children's developmental needs. However, parents with limited economic resources, particularly those living in low-income urban communities, face a chilling, starkly different reality. Rarely is family care an option, and private childcare is not always affordable and/or available. Socioeconomically vulnerable parents have fewer and more limited choices; they often have to rely on government-sponsored care. Finding a secure childcare environment outside of their homes under nonfamilial care in a socioemotionally enriching place for developmental play is unlikely. Instead, these parents too often must choose a childcare setting that provides for the safety of their children but not much more.

Simply put, while all parents are ideally looking for accessible and convenient childcare that both keeps their children safe and enriches them, those with financially meager resources have to weigh the desires differently. With very limited funds, poor parents often have to be hyper-pragmatic about childcare. Unfortunately, that pragmatism can lead them to choose safety as the primary measure of children's health. Recognizing that they cannot afford private care, they make the best decision given their socioeconomic position. They often choose childcare that assures their children's basic safety from outdoor violence. But this type of protective care is unlikely to meet the standard for positive child development and wellness. Further, this type of fundamental care barely meets the bar for quality.

Financially secure parents, on the other hand, can broaden their lens to consider other matters. In contrast to simply protective care, quality care includes physical protection but also provides for children's socioemotional development. But in an economically deprived context, poor urban parents have to consider other variables such as drive-by shootings and stray bullets, the absence of sidewalks, poor lighting, and drug vials as litter in their childcare decisions. Unfortunately, this short-term focus on survival may produce long-term health consequences for children.

The choices of childcare in low-income urban neighborhoods are not simply about the program offerings; even centers that offer the best personalized care are often limited by physical location. Crammed between residential and business districts, too many childcare centers available to poor families do not have sufficient indoor or outdoor spaces for children to move around with ease. Urban childcare centers situated in low-income neighborhoods often exist where the built environment, namely, the neighborhood context, deters physical activity. The centers' social play spaces typically have limited access to outdoor green space. These centers are also unlikely to have large open areas, varied play equipment, or grassy settings designed for sports and other forms of movement such as unstructured play. This absence stymies physical heath, limiting development of gross motor skills. The spontaneity that comes from playing freely leads to improved brain development. When children are given an opportunity to play in enriched environments that include exploration, they have opportunities for planning, organizing, sequencing, decision-making, and creative thinking. In fact, unencumbered play allows children to make determinations about what to play, who can play, when to start, when to stop, and the rules of engagement.[2] Most important, play improves mood and is likely to reinforce more movement and more play. For optimal development, children need space to run and play—space that is not available in many urban childcare centers in low-income neighborhoods. Play-based learning is critical for healthy development of cognitive and social skills as well as physical health. Play is also an important vehicle for enhancing children's learning, and children learn through conscious use of design elements of light, color, texture, sound, and smell.

As a result of the type of childcare available to them, poor urban kids spend their most important developmental years trapped in contained spaces. This confinement may contribute significantly to why urban children in general are more likely to be sedentary than their suburban peers. Kept indoors for safety, these children learn from an early age

that they simply cannot play outdoors. Perhaps the high obesity rates among poor urban children may be traced back to these nurseries. The failure to establish an active lifestyle very early in childhood will likely result in harm to these children that will extend into their adulthood.

FIELD MARKINGS

The first impression of the childcare center in the photograph is unwelcoming. The visibly dilapidated structure lacks color and vibrancy. The windows, covered by closed curtains, allow no natural light to enter. With an absence of light, surveillance cameras, a prisonlike deteriorated exterior, and an absence of places to play, this care center embodies a dream deferred. It seems more suited for the end of life than the beginning of childhood.

The photo illustrates one aspect of the arrested development of poor urban children. This image, in shades of gray and brown, metal and brick, exemplifies the failed promise of American childcare. The visuals do not allow us to imagine that behind these bars and within this decrepit building children of the poor are met with the resources needed to maximize their potential through free exploration and self-discovery. In contrast, the building delivers on the promise to regulate the poor by locking children up tightly indoors. In a few years, these same bars on the windows and doors will become less about keeping children safe from harm from the outside world, and instead will become more about keeping the outside world safe from them.

In fact, the building more closely resembles a prison or an abandoned property than a childcare center tasked with nurturing children's hearts and minds. Young, poor urban children enrolled in such day care centers begin life in a building similar to those used currently in America's more than 1,700 prisons. The children are caged in, separated from the world outside.

Though the barred windows and doors may promise to keep them safe from outside harm, they simultaneously cut children off from the outdoors and all possibilities of exploration. This confinement will likely and subsequently limit their life chances.

The grim facade and lack of any welcoming decor such as planters or colorful signage signal that this facility is not warm and intimate; it is as cold as the steel from which the bars are made. The camera that looms outside the door surveils children and parents. The known presence of the camera clearly declares to those who enter, leave, and pass: "You are being watched." The camera may symbolize the safety that socioeconomically vulnerable parents desire, but, again, this choice is at the cost of healthy child development. Taken together, the camera and the bars communicate that this is a restricted place. At this facility there is no facade of freedom. This is a place of rules and order. Yet we know that the children who are most likely to use this type of group care are precisely those most in need of freedom and opportunities to grow.

The one glimmer of hope comes from the green trees that are in the background of the building. They signal the possibility that there may be a nearby green space to serve as a play area. So despite the building's dilapidated condition, there may be some redeeming qualities that can offset the poor quality of the school's facilities.

FIELD NOTES

Nonmaternal care became popular at the end of the formal U.S. enslavement period as more women were employed outside of their homes. As during slavery, affluent women continued to enjoy private care, while poor working women scrambled to find adequate resources for the care of their children while they were at work. Thus, women have had to be creative in devising strategies to care for their children, as described by Sonya Michel:

Native Americans strapped newborns to cradle boards or carried them in woven slings; Colonial women placed small children in standing stools or go-gins to prevent them from falling into the fireplace. Pioneers on the Midwestern plains laid infants in wooden boxes fastened to the beams of their plows. Southern dirt farmers tethered their runabouts to pegs driven into the soil at the edge of their fields. White southern planters' wives watched African American boys and girls playing in the kitchen yard while their mothers toiled in the cotton fields. African American mothers sang white babies to sleep while their own little ones comforted themselves. Migrant laborers shaded infants in baby tents set in the midst of beet fields. Cannery workers put children to work beside them stringing beans and shelling peas. Shellfish processors sent toddlers to play on the docks, warning them not to go near the water.[3]

The divide between what was available for poor women and rich women was evident.

As early as 1898, philanthropists like New Yorker Josephine Jewell Dodge worked to remediate the situation. She set up a model day nursery in the Children's Building for poor mothers. Progressives such as Jane Addams, also recognizing this gulf between childcare for the rich and childcare for the poor, advocated for more government support for poor mothers. The result was government-subsidized care and an increase in childcare for the urban poor. But despite these efforts, the chasm remained. The children of the affluent continued to attend private nursery schools where they were conscientiously prepared for educational experiences designed to replicate or exceed their class position, while children of the poor were placed in government-sponsored day nurseries where they were taught to be obedient, docile, and accomplished in manual skills.[4]

Over time, government-sponsored childcare became increasingly important for groups of working women, particularly Black women. As their labor force participation increased, they

needed care support for their children. The labor force participation rate of Blacks has increased steadily from about 60 percent in the early 1970s to a peak of 65.8 percent in 2000. The rise in Black women's rates of labor force participation was most pronounced for the mothers of young children, spurring a growing need for childcare.[5] As Karin Brewster and Irene Padavic argue, the higher labor force participation rate among African American women had two contradictory effects: it increased the demand for childcare and also decreased the availability of relatives for care. With the aging of the Black labor force, the number of individuals aged fifty-five and older has grown substantially and is expected to continue growing over the next decade. This has resulted in a dramatic decline of kin care for Black families and more reliance on childcare centers.[6]

Another problem for poor mothers is the reality of what it means to live in urban centers. Cities have the highest poverty rate (18 percent) of all geographic areas. Forty-two U.S. states had higher poverty rates among people living in urban areas than among those living in rural areas.[7] Furthermore, though we may euphemistically talk about urban poor children and urban childcare centers, in reality this conversation is largely about parents and children of color. More specifically, we are talking about African Americans, Latinos, and immigrant families. The Pew Research Center's most recent study shows that since 2000 Whites have become a minority in most urban counties. Immigrants, along with their children and grandchildren, have accounted for the majority of U.S. population growth since 1965, and they are more concentrated in cities and suburbs than in rural areas.[8]

With Latina and African American mothers earning less than their White counterparts, they often rely on government-sponsored childcare programs so that they can find and maintain employment while their children receive care. Therefore, greater attention should be paid to the social environment in which these childcare centers are built and the impact they can have on children's overall health and well-being. Beyond bolstering the incomes of urban

families, policy makers should seek to develop standards for where these centers should be built. We must seek to do more than house children while their parents work; we should develop spaces where children can thrive.

NOTES

1 Kaitlin K. Moran, "Early Childcare Settings and the Parental Enrollment Process: Insights from the Maternal Primary Caregivers of Children Attending High Poverty Urban Childcare Centers" (PhD diss., Temple University, 2014).

2 H. L. Burdette and R. C. Whitaker, "Resurrecting Free Play in Young Children: Looking beyond Fitness and Fatness to Attention, Affiliation, and Affect," *Archives of Pediatric and Adolescent Medicine* 159, no. 1 (2005): 46–50.

3 Sonya Michel, "The History of Child Care in the U.S.," accessed July 23, 2018, https://socialwelfare.library.vcu.edu/programs/child-care-the-american -history/.

4 Michel, "History of Child Care."

5 Daphne Spain and Suzanne Bianchi, *Balancing Act: Motherhood, Marriage, and Employment among American Women* (New York: Russell Sage Foundation, 1996).

6 Karin L. Brewster and Irene Padavic, "No More Kin Care? Change in Black Mothers' Reliance on Relatives for Child Care, 1977–94," *Gender and Society* 16, no. 4 (2002): 546–563; Marlese Durr and Shirley A. Hill, "Guest Editors' Introduction: Special Issue on African American Women: Gender Relations, Work, and the Political Economy in the Twenty-First Century," *Gender and Society* 16, no. 4 (2002): 438–441.

7 U.S. Census Bureau, "A Comparison of Rural and Urban America: Household Income and Poverty," 2016, accessed December 8, 2016, https://www.census.gov/newsroom /blogs/random-samplings/2016/12/a_comparison_of_rura.html.

8 "Pew Research Center Social and Demographic Trends," accessed May 22, 2018, https:// www.pewsocialtrends.org/2018/05/22/demographic-and-economic-trends-in-urban -suburban-and-rural-communities/.

State and North
Third Street

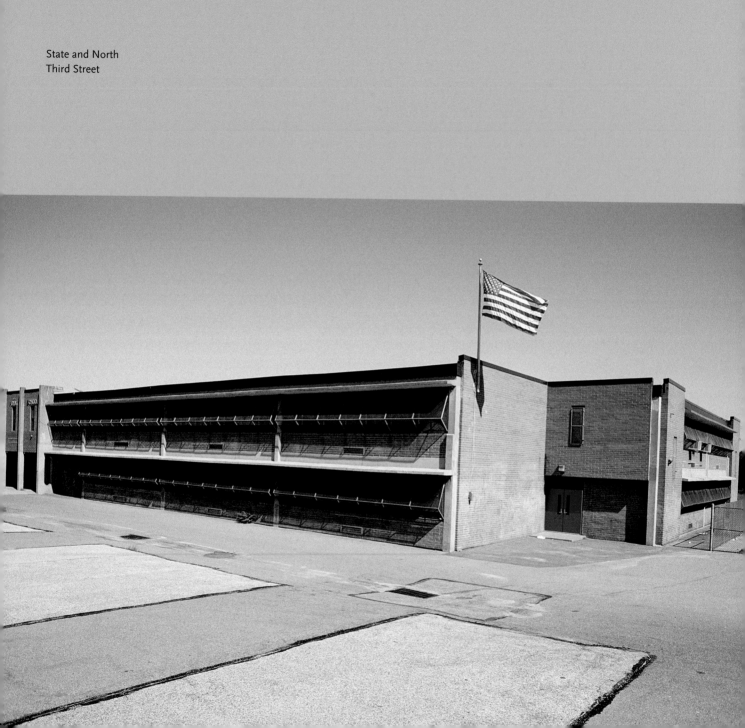

NO. 14 Disinvestment in Urban Schools

LECONTÉ J. DILL

School buildings take up a lot of land mass in American cities. Also, schools and schooling take up a lot of time and space in the lives of young people and their families. School then becomes a major social determinant of health. The evolution of public schools and school systems within cities reflects the sociopolitical histories of these cities. The stereotypical view of public schools is that they are housed in crumbling buildings, with indifferent teachers and troubled students, typically framed as students of color. In the public imagination, we have movies such as *Lean on Me, Stand and Deliver, Dangerous Minds, Coach Carter*, and *Freedom Writers*, which depict urban public schools with chained doors, bars on the windows, limited books, and rowdy students whose only hope for transformation is a lone charismatic teacher or coach. Public schools are deemed as *failing*, and students are too often simply labeled as *failures*, similar to the cities in which they are housed and the residents living there.

The historic and contemporary disinvestment in schools reflects and continues to re-create inequities in our cities and our society. Deindustrialized cities typically are blamed for their levels of physical and economic distress, as if contemporary problems and inequities sporadically and magically appeared only recently, and as if residents are the cause of such distress. In actuality, wealthy elites, bankers, highway and mortgage officials, and developers have influenced national and local city planning policies in this country since the late nineteenth century. These policy makers did not have the best interests of residents at heart. Instead, they were focused on spurring development and controlling the mobility of "disagreeable populations" and "undesirable residents," namely, African Americans, immigrants from Asia and southern

Europe, as well as Catholics and Jews. By the 1930s, these policies effectively restricted capital, mortgage loans, and much-needed renovations in neighborhoods that were redlined—given a poor letter grade and a matching red color on city maps due to the supposed encroachment of such "undesirable residents." In neighborhoods with even a small, but presumably growing, African American population, politicians and bureaucrats withdrew essential services, such as public safety, public transportation, garbage collection, and street repair. These policies and their related practices also constrained mostly working-class African Americans to these very neighborhoods. African Americans could not rent or buy property or even socialize outside of these neighborhoods through the mid-twentieth century—a reality that was enforced with financial sanctions, public signage and blockades, and the threat or enactment of verbal and physical violence. African Americans and the neighborhoods where they were forced to live were deemed blighted. Such instances of blight were seen as problems that residents created and problems that they would have to sort out on their own.

Camden, New Jersey, has been labeled by the media and academics as "distressed," "broken," "crumbling," "fallen," and "failed"; taking this view to its logical extreme, *Rolling Stone* called the city "apocalyptic" in 2013. Although other writers called out the author of the *Rolling Stone* piece for writing "poverty porn," that article managed to tout fear-mongering about Camden, comparing it, in an imperialist American way, to a foreign "other," such as having violence at the levels of Iraq and Afghanistan, and poverty akin to that in Honduras and Haiti.[1] In addition to the city of Camden being maligned, the people living there often are maligned too, with much of the blame being placed on Camden's overwhelming working-class Black and Latinx residents. In reality, this city and its residents have experienced racial residential segregation, economic discrimination and disinvestment, political exploitation, ghettoization, and stigmatization for decades. Since the 1950s, there has been a systematic withdrawal of capital from the city of Camden, followed by White and middle-class flight, with nearby middle-class suburbs frequently disassociating themselves from the city.[2]

The histories of cities and placemaking are rarely studied by the very people who make public education policies decisions there. In the following section, I explore the fortification, surveillance, and lack of safety in urban public schools, using Camden as a case study to elucidate growing urban inequities in the United States.

FIELD MARKINGS

The boxed-in edifice in Vergara's image is heavily bricked, has only a few doors, and its windows are caged. In essence, the building is caged. The building is a cage. In actuality, the building is a school. This building is a school in Camden. This Camden school is caged. This Camden school is a cage. Vergara describes it as a school with "heavy fortification." How have we come to a point in time that our schools are heavily fortified cages?

Sociologist Nikki Jones's ethnography of urban Black girls in Philadelphia shows how they navigate their neighborhood's "code of the street," including a local high school that residents refer to as the "prison on a hill."[3] The school's metal detectors and uniformed guards are reminiscent of the metal detectors and uniformed guards in the city's courts and correctional facilities. Such fortification and surveillance in schools is not unique to Philly or Camden. More and more schools across the country are becoming sterile, brick and concrete environments. Nationally, many students begin their school days with long lines at metal detectors and pat-downs by guards and miss class time as a result. The NYPD's school safety division alone includes close to 5,200 school safety officers and police officers—this is larger than the police departments of some U.S. cities.[4] School guards are ironically called "safety" officers or "security" guards, but they enact surveillance that continues to structure daily life for urban youth. Intrusive body searches, questioning, metal detectors, and cameras are not providing safety for young people in their schools. These same young people who lack safe spaces within their

home neighborhoods also experience a parallel absence in their schools. Their schools become more cages in their lives.

Vergara's school ground image is devoid of humans and play equipment, echoing nationwide trends for the construction of new school buildings without playgrounds. In turn, recess is increasingly rare in the school day, privileging more instructional time. A lack of play has been encoded into educational policy making and into the architecture of schools. A lack of play during the school day has emotional, social, and physical health consequences, such as increased anxiety, stress, depression, interpersonal conflicts, and overweight and obesity.

Playless schools create unsafe spaces for young people. Schools-as-cages do not support young peoples' educational attainment or sense of belonging in schools; they also exacerbate other social inequities in students' lives, such as racism, sexism, and poverty. Zero-tolerance policies discipline and punish students, typically for nonviolent offenses, and are rooted in criminal justice system practices. Specifically designed in the vein of "broken windows" policing, zero-tolerance policies have been enacted in a policy milieu that values strict, uniform punishments of suspension or expulsion above all. Although conservative and neoliberal policy makers and educators hold that such harsh methods are necessary to deter students from breaking school rules, evidence suggests that zero-tolerance policies limit educational achievement and academic self-esteem and increase the prevalence for low-wage work and unemployment. The phenomenon of "school pushout," versus "student dropout," describes the experiences of youth who have been pressured to leave school by the very people, practices, and policies inside of the school.[5] Students are not voluntarily leaving school, but certain students are systematically being "pushed out" of school due to the policies and practices there. Nationally, Black girls are disproportionately suspended and expelled from school at higher rates than other girls, and even at higher rates than White and Asian boys.[6] An intersectional analysis provides a lens to better recognize how contemporary schooling experiences have become manifestations of both

racism and sexism.[7] Black girls are disproportionately labeled as "disruptive" and "deviant" in school and are disproportionately subjected to suspensions and expulsions. Black girls have become hypervisible for punitive policies in schools, but they are nearly invisible for healthy interventions in and outside of their schools.

The American flag adorns the top of the school building in Vergara's image. The Stars and Stripes serve as a reminder that the government is culpable for the state of public education in this country, and that national and local policies have worked to dispossess schools and their students of a quality education in safe environments.

FIELD NOTES

Heavily fortified schools in urban cities reflect the geopolitics of the United States. Camden is at once categorized as an urban area *and* as a New Jersey inner-ring suburb of Philadelphia. Historically, it began as a terminal for Philadelphia's ferry traffic across the Delaware River. Soon, Camden grew as an early industrial center for Campbell's Soup Company, New York Shipbuilding, and RCA Victor in the late nineteenth century. However, the opening of the Benjamin Franklin Bridge across the Delaware River in the 1920s rendered the ferry obsolete and allowed suburban traffic to completely bypass the city of Camden. By the middle of the twentieth century, industries in Camden began to relocate elsewhere in the United States and then outside of the country altogether. Between 1955 and 1980, Camden lost tens of thousands of jobs, and with them, nearly 50,000 residents.[8] However, many of Camden's Black residents stayed in the city, facing housing and job discrimination that constrained their choices regarding mobility within and outside of the city. Describing the ways in which inequality is hidden from view in his hometown of Camden, writer and activist Darnell Moore refutes tropes of

"ghettos" and "hoods" as the fault of its residents of color. Instead, he situates the city's present state within its history of racial residential segregation, overpolicing, economic discrimination, and educational disinvestment:

> It would have been clear I had been brought up in a city crafted into a Black ghetto by unseen hands, characterized as a site of violence and impossibility by past political leaders like Mayor Nardi, his police chief, the city's police force, and the media. I would have understood that the city once erupted because Latino and Black residents were no longer willing to be crushed into neighborhoods too densely populated, enrolled in under-resourced schools, stuck in low-paying jobs, and living under a majority white law enforcement who saw them as bodies fit for extrajudicial liquidation. And to not retell, reclaim, and rewrite that history here would perpetuate the lie that the city I was born into was a hood simply because of the Black and Latino working poor who live there.[9]

This pattern of deindustrialization has rippled across urban and inner-ring suburban centers across the country. What followed in these areas was continual disinvestment in residential real estate through the end of the twentieth century. Additionally, Camden, like Newark, Detroit, Miami, and Los Angeles, experienced race riots and civic uprisings in the mid-twentieth century. The riots in these cities were often in response to police violence against the Black and Latinx residents, and the lack of accountability or justice enacted.

The control of public education has been slowly removed from urban residents over the past forty years. In May 2013, Camden City School District was formally taken over by the State of New Jersey Department of Education.[10] Now, state-mandated, privately run renaissance charter schools, operated by a charter management organization, are being established across the city. Nationally, state-mandated urban school reforms have been fostered through the same

type of redevelopment that is occurring in other postindustrial cities, such as Newark, Detroit, Gary, Philadelphia, and New Orleans.[11] The rental and purchase prices of housing surrounding these new charter schools have continued to soar. Some scholars believe that the growth of charter schools will attract middle-class residents to these gentrifying cities with the promise of "improved" educational systems.[12] In fact, charter schools divert a significant population of students and dollars away from district public schools. Also, charter schools across the nation are associated with the aforementioned zero-tolerance policies. Is the growth of charter schools setting schools and cities up for more surveillance? Are we just manufacturing more cages in neighborhoods? Urban education scholar-activist Bianca Suarez reminds us that "beyond the images of desolate spaces, isolated and dilapidated houses, and deteriorated infrastructure is human life."[13] How can we create more human touchstones?

Overall, schools and the experience of schooling are social determinants of health. Unsupportive educational environments that surveil and punish students only reinforce and exacerbate other social and health inequities.[14] We can work to combat these inequities by dismantling the literal and figurative cages in communities. We must be more diligent about linking city planning research and policy making with urban education research and policy making, and with research, policy making, and interventions that are salient to public health. Although departments of city planning, education, and public health are separate agencies, the leaders of these bodies must begin to better communicate and plan services, interventions, and spaces across cities. They can better share research findings, funding initiatives, and staff expertise across agencies. We can commit to enacting intersectional approaches that center students in schools and in neighborhoods. We can work with families, educators, counselors, and interventionists as part of students' ecosystems. We can build, equip, and staff schools that look and feel like safe havens for students. These healthier schools then will be the centers of neighborhoods that can serve as safe spaces for residents to make homes, and safe spaces for students and their families to feel at home.

NOTES

1 Stephen Danley, "Poverty Porn in Rolling Stone," December 12, 2013, https://danley
.camden.rutgers.edu/2013/12/12/poverty-porn-in-rolling-stone.

2 Neil Smith, Paul Caris, and Elvin Wyly, "The 'Camden Syndrome' and the Menace of
Suburban Decline: Residential Disinvestment and Its Discontents in Camden County,
New Jersey," *Urban Affairs Review* 36, no. 4 (2001): 497–531.

3 Nikki Jones, *Between Good and Ghetto: African American Girls and Inner-City Violence*
(Piscataway, NJ: Rutgers University Press, 2009).

4 Kimberlé Crenshaw, Priscilla Ocen, and Jyoti Nanda, *Black Girls Matter: Pushed Out,
Overpoliced and Underprotected* (New York: African American Policy Forum, 2015).

5 Monique Morris, *Pushout: The Criminalization of Black Girls in Schools* (New York:
New Press, 2016).

6 U.S. Department of Education, Office for Civil Rights, *Civil Rights Data Collection Data
Snapshot: School Discipline*, Issue Brief No. 1 (Washington, DC: U.S. Department of
Education, 2014).

7 LeConté J. Dill, Shavaun Sutton, Bianca Rivera, and Mira Grice Sheff, "'No One Asked
How School Was Going': School Pushout as a Structural Determinant of Health for
Urban Black Girls" (unpublished manuscript, 2020).

8 Joan Maya Mazelis and Andrew Seligsohn, "Deindustrialized Small Cities and Poverty:
The View from Camden," in *The Routledge Handbook of Poverty in the United States*,
ed. Stephen Haymes, Maria Vidal De Haymes, and Reuben Miller (New York: Routledge,
2014), 58–64.

9 Darnell L. Moore, *No Ashes in the Fire: Coming of Age Black and Free in America*
(New York: Nation Books, 2018).

10 Mazelis and Seligsohn, "View from Camden," 30.

11 Bianca A. Suarez, "The Taking of the Darker Cities: The Detroit Public Schools Take-over and the Neoliberal State" (paper presented at the annual meeting of the American Education Research Association, Vancouver, Canada, April 13–17, 2012).

12 Keith E. Benson, "Better for Whom? Present and Prospective Camden Resident Perspectives' on State-Mandated Renaissance Charter Schools and Recent Camden Development" (PhD diss., Rutgers University, 2016).

13 Suarez, "Darker Cities," 1.

14 Dill et al., "How School Was Going," 3.

Along South Fourth
Street from
Whitman Avenue,
2005

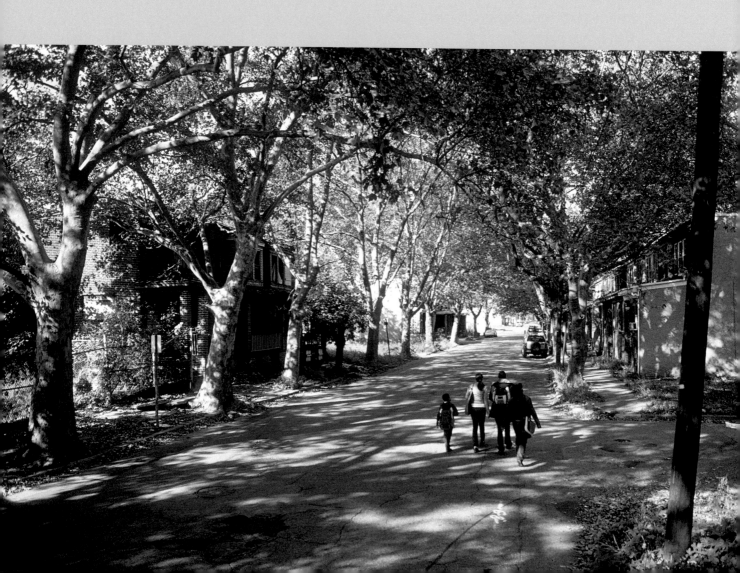

NO. 15 Racism in Law Enforcement

CRAIG B. FUTTERMAN, CHACLYN HUNT, AND JAMIE KALVEN

Since the summer of 2014, when the police shooting of Michael Brown in Ferguson, Missouri, first commanded public attention, our country has been engaged in what some have described as a national conversation about racial disparities in the criminal justice system. The press tends reflexively to describe matters of grave concern as crises. By definition, a crisis is a departure from the norm. What we are confronting, however, is not a departure from the norm but the very nature of the norm.

In the fall of 2015, a county judge in Chicago ordered the release of the horrifying video of Chicago police officer Jason Van Dyke's murder of seventeen-year-old Laquan McDonald. Millions of people around the world viewed the footage of an on-duty police officer firing sixteen bullets into the body of the Black teenager, almost all of them while the boy lay helpless on the ground. The forced release of the video and other records related to the shooting lifted the curtain on the Chicago Police Department's machinery of denial and began to wake White Chicago and the nation to the realities of systemic police abuse of Black Americans and the code of silence that protects it. As protests engulfed Chicago's Magnificent Mile on the busiest shopping day of the year, with young people shouting, "Sixteen shots and a cover-up," public debate raged about patterns of police abuse and impunity, a discourse extending back to the 1960s and beyond. Four years later, Officer Van Dyke was convicted of second-degree murder and sixteen counts of aggravated battery with a firearm. This is the first time that an on-duty Chicago police officer has ever been held criminally accountable for killing a Black person. The

McDonald case, like the lengthening series of cases that have riven the country, is at once a national issue and an intensely local one. The federal government has a significant role to play in articulating national norms, imposing uniform standards, and intervening in local jurisdictions to address civil rights violations. Ultimately, though, the desired structural and cultural changes will require intense, sustained engagement of citizens with one another and their governments in the places where they live.

FIELD MARKINGS

What the children in the photograph appear to be doing—walking home from school—should be an unremarkable part of their daily lives. Although we do not know the nature of the relationships among them, this photograph has captured the children walking in a leisurely manner, the older ones leading the way, younger siblings or friends in tow. The tree canopy provides shelter on a late summer or early fall day, and despite some evidence of disinvestment (e.g., weedy vacant lots, houses boarded up and in disrepair), the group has an air of safety and comfort in their community. If so, it is a privilege that too often goes unrealized for Black and Brown children and teenagers in U.S. cities, who must contend with ubiquitous, and sometimes brutal, intrusions by police officers into their privacy, happiness, and well-being.

FIELD NOTES

Nowhere is the intrusiveness of police in the lives of adolescents more evident than on the South Side of Chicago. For several years, the Mandel Legal Aid Clinic of the University of

Chicago Law School and the Invisible Institute have engaged in conversations with Black high school students on the South Side about their experiences with the police in their neighborhoods. Focusing this inquiry on everyday encounters rather than egregious instances of abuse, and avoiding conventional policy frames (e.g., "stop and frisk"), we asked teens to describe interactions with police in their own words, exploring the feelings and behaviors these encounters evoke.

Under the leadership of instructor Keva McGee, the Media Broadcast Program at Hyde Park Academy High School (HPA) was our base of operations, affording a classroom, a broadcast studio, and ongoing access to groups of students. A team of a dozen adult collaborators—including attorneys, law students, journalists, and academics—worked weekly with HPA classes throughout the school year. Each week the team met for a debrief on their sessions with students and to strategize about facilitating the conditions for robust, searching conversations. Teens on the South Side are of necessity close observers of the police, and some have proved to be remarkable witnesses to their own experience.

Put simply, a different set of rules and norms governs encounters between Black high school students and the police in their neighborhoods than those we experience and teach at the law school. It is as though we live in separate worlds and inhabit different realities. Officers regularly subject youths to rituals of stops, questions, searches, and arrests. The encounters feel random, yet they are contained within racially and economically segregated areas, and so have the effect of creating a pervasive atmosphere—a constant threat.

The kids we worked with ranged from fourteen to eighteen years old. For some, being stopped was "an everyday thing."[1] For others, it was a relatively infrequent occurrence. For all, it was an ever-present possibility, with scarcely a moment absent vigilance to that possibility. Police stops—at once utterly prosaic, a fact of life "like the weather," and fraught with danger—pervaded their daily existence. Students described as routine hostile encounters in which officers commanded them to put their hands against a wall and spread their legs to be searched.

Everything about these encounters—from the officers' body language as they approached to their tone of voice—appeared, from the students' perspectives, to be calculated to convey messages of power and authority. Time and again, students told us, "They have all the power." Hassanti, a high school junior, describes a typical encounter: "I'll just be walking with my friends or something. Or I could be walking by myself. And then they pull up. . . . 'Get on the car!' Or, 'Get on the wall!' 'Spread your legs. Put your hands up. Put your hands on the gate. Don't move.' Searching my pockets."

Many stops were low-key encounters, but youths also experienced the aggressive performance art of the so-called jump-out boys, plainclothes officers for whom a routine street stop often took the form of driving their car up on the sidewalk and jumping out with guns drawn. These officers were often known by street names, their actual names obscured from public scrutiny. Carl: "I done seen people being pulled over, and the police walk up to the car with their guns out, with the flashlight. They walk up to the car with the guns out. I don't get that."

Routine encounters involved questions from officers about who they were, where they lived, who their friends were, and what "type" of kids they were. Although the questions were superficially innocuous, as an ongoing narrative they express an underlying suspicion. When the same questions are posed day after day, the message becomes clear. Merely *being* someone somewhere is enough to merit investigation. Desiree: "It was two officers. They came up to us with . . . you know, they came on to us aggressive anyway, like always. I mean sometimes police approach in a different way, but the majority of the time, it's simply aggression. They're just like, 'What are you doing over here? How old are you? What school do you go to?' And those are just the basic questions." Christopher: "They stopped us, and they asked me where the fuck I'm going. Then that's when they went in my pockets, threw my keys, and took my money."

Individual police encounters were also contextualized by the experiences of the students' family members and friends, the teachings and caution of their elders, and information they have absorbed from the media. Nearly every student had a friend or family member who had been beaten, arrested, tased, or shot at the hands of the police. These youths had deeply internalized what the rest of society is only beginning to comprehend in light of high-profile shooting cases: no matter how "routine" it begins, every police encounter holds the potential to escalate into something far worse—a false arrest, years in prison, brutality, even death.

Jazmine, a boisterous senior girl who was friendly with everyone in class, had a friend who was shot by the police. He had run away from the police, and they shot him with a Taser as he attempted to climb over a fence. As he was lying on the ground stunned, a police officer shot and killed him. Nothing happened to the police officer. Ever since getting the news, Jazmine has experienced a physical reaction akin to post-traumatic stress disorder whenever she is around police. As she describes it: "It's scary because you don't know what's gonna happen next. So, when it's going on . . . my heart will be beating real fast, I'll be scared, my legs'll be shaking. . . . I'll be like, 'What's gonna happen if I do something wrong, if I move a certain way, and they interpret it wrong?' They might . . . pull out a gun. . . . You hear it in my voice, like it's trembling."

Jazmine's fear is rooted in her vulnerability. She knows she is unable to control the outcome of any interaction she has with officers—simply avoiding criminal behavior is not enough to guarantee a good result. This was a common understanding among the Black teenagers we worked with on the South Side—regardless of any effort they may make to pacify officers, once detained, the situation is largely out of their control. Students report that they assert themselves at their own peril. We tend to think of police misconduct as a linear continuum with mild forms at one end and grievous human rights violations at the opposite extreme, but that is

not the way it is experienced on the ground. Under conditions of impunity, the worst things that have happened inform the day-to-day interactions.

A major theme running through our conversations was how to avoid being stopped. It was as if the kids were trying to discern and decode a hidden set of rules, a secret etiquette that would enable them to move freely through the city. Kids reported that gender stereotypes matter: the more officers perceive students as masculine, the more likely they may be stopped and abused. Malik, a large wrestler, told us that he wears "hipster" styles to avoid police scrutiny: "My jeans will be fitted. If I have a hoodie on, it wouldn't be dark. It'll be a bright red or purple or something like that with designs on it."[2] He notes that styles he perceives as more masculine like "really baggy pants, big hoodies, things like baggy clothes in general are suspicious to the police."

And we repeatedly hear about boys who used girls as decoys—by appearing to be a couple—when the police come into view. Doing so, young men claim, means they appear sensitive, caring, and sweet—all qualities that are believed to be antithetical to a police officer's idea of a criminal.

Tytania said that when they are in public, her six-foot-two linebacker boyfriend routinely carried her pink "Hello Kitty" book bag: "If we are somewhere where there are police, he usually just puts his arm around me, so it's just like nothing. He carries my book bag, I guess they're like, 'She's with him.' I don't know. It's like the book bag is, I don't know, innocence or something. . . . He doesn't smile a lot when we're outside. And the way he walks. . . . I just think he'll get stopped if he didn't have me around.

Yet, providing cover for a young man can put young women in danger, because a man who poorly performs romance attracts police attention toward both himself and the woman covering for him. Portia opined that, if the man is too obvious about initiating cover, then the police will "see that he grabbed you, and they're like, 'He's probably got something on him. Let's go

over to him.' . . . If you would have just stayed calm, then nothing would have happened." The boundaries between what is normal and what is suspicious seem to change daily, depending on the neighborhood, the officer, and the teenager.

But being deferential was not always an advantage—in fact, it can put one in danger with his peers. Demonstrating aggressive masculinity helps to protect Alajuwon from his peers, but doing so increases his chance of being stopped by the police. But, by playing a servile role to avoid police, he makes himself more vulnerable to attack by others. Alajuwon: "[I grew up] in that type of neighborhood where you can't show nobody that you're weak, you go in bad or you get beat up . . . [but] with the police, it's kind of hard to switch it on and off. Going to school every day I've got to be this big, bad person, and then I gotta go home, act like I'm a goody-two-shoe."

Driana was walking with her younger brother after school one day when a small group of young men began to follow them, jeering and calling out insults.[3] Driana called the police, but no one arrived, and her brother was jumped and badly beaten. She called the police several times, and, after almost three hours, two officers arrived at her home. Though her parents were not home, the officers entered her house, tore apart her brother's room, interrogated him, put him in handcuffs, and threatened to arrest him. They did not fill out a report on his assault. When asked how she handles bad situations now, Driana smiles and says, "I have cousins."

It is rarely acknowledged that a lack of police accountability imperils how law enforcement itself functions. More than anything, we were struck by how alienated so many of the students felt from law enforcement—their sense of injury, their fundamental distrust of the police. Some were so alienated from, unprotected by, or even threatened by police that they argued they would be safer if they could abolish the police altogether.

Distrust of the police sets in motion a cycle with devastating effects for our children's safety, sometimes with grave consequences. Because kids do not trust police, they will not call them

for help when they are in trouble. Because people will not cooperate with the police, the police cannot solve and prevent crimes. Because the police cannot solve and prevent crimes, residents are yet less likely to go to the police and more likely to look for resolution or restitution outside the law. In the absence of meaningful accountability, the cycle goes on and on, reducing urban neighborhoods to something akin to failed states.[4]

Just as the experiences of the young people most affected by urban police practices inform our diagnoses, they also inform the cure. Distrust of the police arises from experiences with a lack of accountability, unequal treatment, and a reality of ongoing racism, institutional denial, and impunity. The students taught us that the path to change must begin with acknowledging those realities. Until we do so, real change is not possible. Pushing past denial is not easy. It requires acknowledging White privilege, sustaining conversations on the difficult subject of race, and grappling with the experiences of "others" who have been cast as "less than." Once we do so, however, the path becomes clear. Black high school students have shown us that we must embrace principles of honesty and transparency, implement a credible regime of accountability in response to students' experiences with police impunity, and build a relationship based on shared power and respect for the dignity of young Black people.

In the final analysis, the most important thing that police can do to earn the confidence of our kids is simply to "quit it." Stop harassing, arresting, brutalizing, and killing so many Black people.

NOTES

1 All quoted interviews come from the Youth/Police Project in Chicago, Illinois.

2 Interview with Malik, Youth/Police Project, Chicago, Illinois, May 4, 2014.

3 Field notes, Youth/Police Project at Hyde Park Academy, Chicago, Illinois, spring quarter, 2011–2012.

4 Chicago data from the Citizens Police Data Project reveal that police are least successful
in addressing crime in the areas in which they have the least trust. See graph, Chicago
Police Misconduct Complaints, as compared with Clearance Rates for Violent Crime by
Neighborhood (2011–2015), on file with the authors and drawn from City of Chicago
Data Portal Crimes 2011–2015 and the Citizens Police Data Project (showing that the
neighborhoods in the city with the lowest clearance rates for violent crime also have the
most complaints of police abuse).

ACKNOWLEDGMENTS

This book grew out of a conference I organized in 2016 while I was the associate director of the Center for Race and Ethnicity at Rutgers University. The conference, "The City as Health Policy," examined the ways in which city policies and infrastructure promote or hinder health, even if at first blush those policies are ostensibly at some remove from health. For example, law enforcement policies such as stop and frisk are in fact health policies because of the stress, anxiety, and trauma they engender, and the collateral consequences they produce (e.g., job loss). The conference was funded by the Robert Wood Johnson Foundation and was informed by its "Culture of Health" framework. This book riffs on those themes, exploring the city and inequality within it, inclusive of, but not limited to, health.

I must therefore first thank the Robert Wood Johnson Foundation and the folks at that time who made possible the funding that enabled the conference: my program officer, Jasmine N. Hall Ratliff, and three others at the Foundation, Christine Nieves, Dwayne Proctor, and Paul Tarini, who first helped me shape my ideas. Colleagues who were at the Center for Race and Ethnicity at that time helped bring the project to fruition and also deserve many thanks: Professors Mia Bay and Ann Fabian, and the graduate assistant cohort that year, Jesse Bayker, Sally Bonet, Grace Howard, Rosemary Ndubuizu, and Hakim Zainiddinov.

After percolating for some time, the ideas for this book began to take more concrete shape while I had the fortune of being a fellow at the Institute for Advanced Studies at Aix-Marseille Université (IMéRA) in Marseille, France. I spent a wonderful year in residence there thanks to the European Institutes of Advanced Studies (EURIAS), under the leadership of Dr. Raouf Boucekkine.

Thanks to Camilo José Vergara, whose work I have long admired, for collaborating on this project. It is still not really clear to me how he managed so comprehensive a study of so many cities, but I am glad he did. Darnell L. Moore graciously agreed to write the foreword, taking time out of an incredibly busy schedule to pen an incredibly moving testimony to Camden, its history, and the analysis in this book. Peter Mickulas, my editor at Rutgers University Press, was a fount of enthusiasm, insight, and expert guidance of the project from start to finish.

Finally, I want to acknowledge Ann Petry, author of the indelible Harlem novel *The Street*, in homage to which this book is titled.

NOTES ON CONTRIBUTORS

ANTHONY S. ALVAREZ is assistant professor of sociology at California State University, Fullerton. His primary interests are in economic sociology, inequality, poverty and social policy. His research focuses on how networks impact economic behavior and patterns of inequality. He is the coauthor of *Credit Where It's Due: Rethinking Financial Citizenship* (with Frederick F. Wherry and Kristin S. Seefeldt), which examines the use of lending circles to improve credit access by the Mission Asset Fund, a nonprofit in San Francisco. His work has been published in *Social Forces, Annual Review of Sociology, Social Science Quarterly*, and *Monthly Labor Review*.

JANICE JOHNSON DIAS is associate professor of sociology and a member of the graduate faculty in the Department of Criminal Justice at John Jay College. Johnson Dias holds a PhD in sociology from Temple University; she completed her postdoctoral study at the University of Michigan, Gerald R. Ford School of Public Policy, National Poverty Center. Her research focuses on mothers and children who grew up in and/or are currently living in poverty. In addition to her academic work, Johnson Dias is the founder and serves as the president of the GrassROOTS Community Foundation (GCF), a national training organization with a focus on public health and social justice. GCF supports, develops, and scales community-driven solutions to the health challenges facing women and girls. It garnered the attention of the Obama White House and has received financial support from funders including the Annie E. Casey Foundation, the Robert Wood Johnson Foundation, RWJBarnabas Health System, MasterCard, JP Morgan Chase, and GlaxoSmithKline. Johnson Dias also works closely with policy

makers to bring academic research to bear on public policy and has served as an adviser to several government officials, including Mayor Ras J. Baraka of Newark, New Jersey; Mayor Adrian O. Mapp of Plainfield, New Jersey; and Pennsylvania state representative Stephen Kinsey. Her most recent work supporting the need for diverse literature through the #1000BlackGirlBooks campaign has been featured in the *Wall Street Journal*, *Teen Vogue*, *Forbes*, and the *New York Times*, and on CNN and many national and international outlets.

LECONTÉ J. DILL is a native of South Central Los Angeles and is currently creating a homeplace in Bed-Stuy, Brooklyn. She holds degrees from Spelman College, UCLA, and UC Berkeley and is a scholar, an educator, and a poet focusing on urban Black girl wellness. Currently, she is clinical associate professor in the Department of Social and Behavioral Sciences, and director of public health practice at the New York University College of Global Public Health.

ZAIRE Z. DINZEY-FLORES is associate professor of sociology at Rutgers, The State University of New Jersey. Her research focuses on understanding how urban space mediates community life and race, class, and social inequality. Her 2013 book, *Locked In, Locked Out: Gated Communities in a Puerto Rican City*, co-won the 2014 Robert E. Park Award of the Community and Urban Sociology Section of the American Sociological Association. She is working on a book examining how race is articulated in residential real estate practices in Brooklyn, New York. She is also a member of the Black Latinas Know Collective.

MINDY THOMPSON FULLILOVE is a professor of urban policy and health at The New School. She is a board-certified psychiatrist, having received her training at New York Hospital–Westchester Division (1978–1981) and Montefiore Hospital (1981–1982). She was a research psychiatrist at the New York State Psychiatric Institute and on the faculty of Columbia University from 1990 to 2016. She has studied epidemics of poor communities, as well as ways to repair

them, and has published more than one hundred articles and six books including *The House of Joshua: Meditations on Family and Place*; *Root Shock: How Tearing Up City Neighborhoods Hurts America and What We Can Do about It*; and *Urban Alchemy: Restoring Joy in America's Sorted-Out Cities*. She has received many awards for her work, including inclusion in the "Best Doctors in New York," two honorary doctorates (Chatham College, 1999; Bank Street College of Education, 2002), and election to honorary membership in the American Institute of Architects.

CRAIG B. FUTTERMAN is clinical professor of law at the University of Chicago Law School. He founded and has served as the director of the Civil Rights and Police Accountability Project of the Mandel Legal Aid Clinic since 2000. Before his appointment to the law faculty, Professor Futterman was a lecturer in law and director of Public Interest Programs at Stanford Law School. He previously joined Futterman & Howard, Chtd., a boutique law firm concentrating in complex federal litigation. There, he specialized in civil rights and constitutional matters, with a special focus on racial discrimination, education, and police brutality. Before that, he served as a trial attorney in the Juvenile Division of the Cook County Public Defender's Office. He received his JD from Stanford Law School and graduated with the highest distinction from Northwestern University with a bachelor of arts in sociology and economics.

NORMAN W. GARRICK is professor in the Department of Civil Engineering and codirector of the Sustainable Cities Research Group at the University of Connecticut. In these roles he has led groundbreaking research on street networks and their impacts on pedestrian safety, car travel, and the health of citizens; the evolution of parking provision in cities and its impact on the urban fabric; the widening gaps between the United States and other developed countries in terms of traffic fatality; and the design and operations of streets based on shared space concepts. His research has been featured in such forums as the *Washington Post*, The Atlantic

CityLab, *The Guardian* (UK), Planetizen, Bloomberg BusinessWeek, FiveThirtyEight.com, Vox.com, StreetsBlog, Mic.com, StreetFilms, National Public Radio, and Australian Public Radio. He was a 2004 Fulbright fellow, is a fellow of the Congress for the New Urbanism, and has twice been invited to serve as a visiting professor at the Swiss Federal Institute of Technology (ETH) in Zurich. Garrick has consulted with design teams on a range of projects around the world, including planning for post–Hurricane Katrina reconstruction in Mississippi; redevelopment in Freetown, Sierra Leone, and Kingston, Jamaica; and freeway, transit, and parking planning across the United States.

CHACLYN HUNT is a civil rights attorney with the Invisible Institute, an investigative journalism organization from the South Side of Chicago. She codirects both the Youth / Police Project and the Citizens Police Data Project.

JAMIE KALVEN is a journalist and executive director of the Invisible Institute, an investigative journalism organization on the South Side of Chicago.

NAA OYO A. KWATE is associate professor of Africana studies and human ecology at Rutgers, The State University of New Jersey. A psychologist by training, she is an interdisciplinary scholar with wide-ranging interests in racial inequality and African American health. Her research has centered primarily on race, urban built environments, and the direct and indirect effects of racism on African American health. Her research has been funded by the National Institutes of Health and the Robert Wood Johnson Foundation, and she has been a fellow at the Black Metropolis Research Consortium, the Smithsonian Institution, and the Institute for Advanced Studies at Aix-Marseille Université, France. In 2019, she published *Burgers in Blackface: Anti-Black Restaurants Then and Now.*

ALECIA J. MCGREGOR is assistant professor of community health at Tufts University, where she is also affiliated with Africana studies and the Program in Science, Technology and Society. She received her PhD from Harvard University in 2014, with a certificate in Latin American studies. From 2014 to 2016, she was a postdoctoral research associate in the Center for Health and Wellbeing at Princeton University. At Princeton, she helped launch an initiative on race, inequality and health policy in the United States. She has published and lectured internationally on the plight of marginalized communities vis-à-vis access to health care. Her work focuses on the political determinants of health, health systems and health inequalities, and religion, race, and health politics in the United States and Brazil and across the African Diaspora. Her current research focuses on the drivers and consequences of hospital closures in the United States.

DARNELL L. MOORE is the director of inclusion strategy for content and marketing at Netflix. He is the former head of strategy and programs (U.S.) for Breakthrough TV, editor-at-large at CASSIUS (an iOne digital platform), and senior editor and correspondent at Mic. He is the co–managing editor at The Feminist Wire and the writer-in-residence at the Center on African American Religion, Sexual Politics, and Social Justice at Columbia University. Moore's advocacy centers on marginal identity, youth development, and other social justice issues in the United States and abroad. Named one of The Root 100's most influential African Americans, Moore is a prolific writer. He has been published in various media outlets, including MSNBC, *The Guardian*, *Huffington Post*, *EBONY*, *The Root*, *The Advocate*, and *OUT* Magazine. His first book, *No Ashes in the Fire*, was published in 2018 and won the Lambda Literary Award (Gay Memoir/Biography) in 2019.

JACQUELINE OLVERA is assistant professor in the Department of Sociology at Adelphi University. She holds a PhD in sociology from Stanford University and a master of science degree

in policy analysis and management from Carnegie Mellon University. Her expertise lies in the areas of organizations, urban inequality, migration, and social policy. Olvera's work has appeared in *City and Community, Journal of Poverty, International Migration,* and other peer-reviewed journals. Her most recent project, funded by the Russell Sage Foundation, is a qualitative study of the stigma of illegality in everyday life, the actors involved in its management, and the institutions that support it.

JAY A. PEARSON is assistant professor at Duke University's Sanford School of Public Policy. Hailing from rural eastern North Carolina and with training in health behavior, social epidemiology, and health demography, Pearson has lived and worked in a diverse range of communities and sociocultural contexts both in the United States and abroad. His research, teaching, and advocacy interests address the historical role of public policy decision-making in majority/minority identity construction, social stratification, structural and institutional social bias, and the identity-mediated population health effects associated with the lived experience, physical embodiment, and biological embedding of these processes.

JACOB S. RUGH is associate professor of sociology at Brigham Young University, where he joined the faculty in 2012. He received a dual master's degree in public affairs and urban and regional planning and a PhD in public affairs from Princeton University. His research focuses on race, neighborhood space, and immigration, with an emphasis on housing segregation and homeownership. His most recent article, "Why Black and Latino Homeownership Matter to the Color Line and Multiracial Democracy," was published in *Race and Social Problems*. Rugh engages in conversations and leads trainings on race with student and faculty groups, academic advisers, city officials, and other universities. He also consults on fair lending and housing discrimination civil rights cases. Raised on Chicago's South Side, he credits his father's

legacy, along with living in affordable housing and attending integrated public schools, as his inspiration to fight for racial equality.

STACEY SUTTON is assistant professor of urban planning and policy in the College of Urban Planning and Public Affairs and faculty fellow in the Institute for Research on Race and Public Policy at the University of Illinois at Chicago. Her primary areas of research include community economic development, economic democracy, neighborhood and small business dynamics, and racially disparate effects of place-based policies. These interests have led her to explore how Black-owned businesses shape and are shaped by neighborhood decline and renewal; why enforcement of mundane land-use rules, building inspections, and zoning rules frequently hasten the shuttering of small, Black-owned businesses; the racial dimensions of gentrification; and racial patterns associated with place-based policies. Sutton holds a joint PhD in urban planning and sociology from Rutgers University and an MBA from New York University.

CAMILO JOSÉ VERGARA is one of the nation's foremost urban documentarians. He is a recipient of the 2012 National Humanities Medal (awarded by President Barack Obama) and was named a MacArthur Fellow in 2002. Drawn to America's inner cities, Vergara began recording New York City's urban landscape in 1970, the year he settled there. Since 1977, he has systematically photographed some of the country's most impoverished neighborhoods, repeatedly returning to locations in New York, Newark, Camden, Detroit, Gary, Chicago, and Los Angeles. Vergara lectures widely and is the author of numerous books and essays. His photographs have been the focus of nearly a dozen exhibitions and have been acquired by institutions nationwide. The Library of Congress will be the permanent home of his photographic archive. Born in Santiago, Chile, Vergara earned degrees in sociology from the University of Notre Dame (BA, 1968) and Columbia University (MA, 1977).

KELLEE WHITE is associate professor in the School of Public Health (Department of Health Services Administration) and assistant director in the Maryland Center for Health Equity. She earned her PhD (epidemiology) and MPH (sociomedical sciences) from Columbia University's Mailman School of Public Health and was a W. K. Kellogg Postdoctoral Scholar at the Harvard T. H. Chan School of Public Health. Before joining the University of Maryland, she was on the faculty at the University of South Carolina Arnold School of Public Health in the Department of Epidemiology and Biostatistics. Her research focuses broadly on institutionalized racism and population health. Scholarly work to date has contributed to furthering the understanding of conceptual and methodological issues related to racial/ethnic segregation and health and reforms in housing policy legislation, regulation, and implementation as an important strategy to achieve health equity. Additionally, her research explores the social determinants of multiple chronic conditions with an emphasis on healthy aging among middle-aged and older adults.